HIGH SCHOOL SENIOR
Portrait Photography

D1402725

John Giolas, CR. Photog. CPP

AMHERST MEDIA, INC. ■ BUFFALO, NEW YORK

Published by:
Amherst Media, Inc.
P.O. Box 586
Amherst, NY 14226
Fax: (716) 874-4508

Publisher: Craig Alesse
Senior Editor/Project Manager: Richard Lynch
Associate Editor: Frances J. Hagen
Photos by: John Bir, CPP., of John Giolas Photographers, Inc.

ISBN: 0-936262-83-4
Library of Congress Card Catalog Number: 98-74043

Printed in the United States of America
10 9 8 7 6 5 4 3 2 1

Table of Contents

Introduction

"...address all aspects of high school senior photography."

This book will address all aspects of high school senior photography. You will find out why you might want to do senior photography. You will learn how to decide whether you are going to be a contract photographer or go after business on an individual basis.

When you make your decision, you will learn what you need to do, no matter which route you decide to take. Included in this book will be actual presentations given to a school year book committee in an effort to get their business.

As we progress, you will go into our camera room and learn what we do and how we do it. You will be shown how to set up and light every pose. You will find out how to make some of the props we use and where to get the material for them. Finally, it is the goal of this book to teach you how to do quality senior portraits in an assembly line system, which allows me to photograph from 1400 to 1600 seniors each year from June through November.

When you are done with this book, you will know how to get seniors to come to your studio, what to do when you get them there and how to keep them coming back.

These seniors are like the branches of a tree reaching out to you later in life as you nourish them by recording an ongoing supply of the precious moments of their lives. And, each year there is another class going forth and multiplying as they get engaged, get married, and start families. Hence a solid customer base for you.

A special thank you goes to John Bir CPP. of John Giolas Photographers for supplying all of the photographs for this book.

CHAPTER ONE

Getting into the Senior Portrait Business

"He barked, he meowed, he crawled, he giggled ..."

First you must decide if photographing seniors is really what you want to do. Not everyone feels the way I do. To illustrate this point, I am reminded of the time I visited another photographer.

On most of my vacations, I try to manage a visit to a studio. A few years ago, I visited a studio which specialized in children's photography. The owner photographer asked me if I wanted to watch him do a sitting, and of course I said yes. I watched in amazement while this man went through a series of totally mind boggling events as he brought out the very best in that child. He barked, he meowed, he crawled, he giggled, he laughed, as he got down to that child's level and totally humiliated himself.

This man was very good at what he did. The child, the mom and I were laughing and having a great time. All of us were entertained as this photographer went through his normal routine. I remembered saying to myself how I could never be that much of a clown. I kind of felt sorry for this photographer who had to go through so much agony on a daily basis to get some great expressions. Then he asked me if I liked what I witnessed, to which I replied, "You were fantastic." He then asked, "By the way, what is your specialty?" To which I proudly answered, "I specialize in senior portrait photography." "Yuck," he exclaimed, "I hate seniors. You'd never catch me doing seniors." He went on, "How can you work with those hard to deal with kids?"

Reasons for Photographing Seniors

- Seniors all have to get photographed to appear in the yearbook.

- You are building a good customer base. Many of these seniors will become engaged, get married, and have children. If you did a decent job on their senior picture, they will at least start with you when they are planning

to get married. Think of it, every year you are getting a new crop, and they go forth and multiply, at the average rate of two children per family. Like the branches of a tree, these seniors will become your growing customer base. And as you provide them with memories, they will return to you as lifetime customers. If you are convinced seniors are what you want to do let's find out what needs to be done.

Contract vs. Non-contract

• **Planning is an essential ingredient to starting your own successful small business.**

Before we continue, we must decide which avenue to go down relative to the contract vs. the non-contract photographer. I have been on both sides of the fence and so what I tell you now comes from my experiences with each side.

The Contract

In most cases, you are required to contribute a given amount to the yearbook fund, which can be can be arrived at various ways:

 1. It can be a percentage of all your sales.

 2. It can be a per head price.

 3. It can be a guaranteed flat rate.

In addition, you must supply the school with all film and darkroom supplies needed for them to take and print their own yearbook pictures. You must also cover any event lined up by the yearbook adviser, process and print all film exposed by student photographers, and have a mini-workshop for yearbook photographers. Finally, you must furnish the school with one glossy of each senior.

In return, the school will furnish you with a list of all seniors, and agrees to inform all seniors that in order to appear in the yearbook they must be photographed by you. However, "you are under no obligation to purchase photographs." The school will also notify juniors before school is out that they will be getting their appointments from you in early summer as the official yearbook studio.

Each school you contract with is a different situation. What you give up to get the contract is strictly up to you. How bad do you want it? How big is the class? How many years is the contract? What economic levels do these kids come from? If you choose the contract avenue, you need to get an appointment with the principal. You need to show a client good samples, good prices, and make him/her aware of all the reasons why he/she should choose your studio. You must above all be honest with yourself. If you got the contract, could you handle the volume?

Many times principals will set up a committee to decide who gets the contract. On that committee, you may have a principal, the yearbook adviser, some parents, and some students from each class affected by the contract.

Here is what the committee will want to know:

Principals want to know the financial figures relative to what the school will get.

Advisers want to know:
1. When their senior pictures will be ready to be sent to the printer.

2. How many school events will you cover.

3. How soon after you cover an event they will get their glossies.

4. How much film and supplies they will be allotted.

5. If you will process film shot by the students.

Parents want to know:
1. The cost of packages.

2. How much the sitting fees will be.

3. If the sitting fee will apply toward the package prices..

4. If you will shoot re-takes.

5. What your refund policy is.

Students want to know:
1. How many backgrounds you offer.

2. What your special effects are.

3. How many changes of clothing they are allowed

4. How many poses in each of the sittings.

What to Say to Whom

When you confront a principal, stress that you are local, which will take all of the complaint heat off him (parents will have a local studio to visit and take care of any problems), and that you are ready and willing to compete on the national studio's terms.

To an adviser, emphasize fast delivery on all activity pictures taken by you or the yearbook staff. If the adviser is handling the business, tell him or her about the financial help you will provide.

To a parent, talk about prices, extras, give-aways, retouching, bonuses, and a re-sitting policy. Parents will tend to be price-conscious.

Tell the students about what interests them most — your poses, backgrounds and your special effects, all about your props, and the fact that they can bring in their own props.

Sample Presentation

Rather than try to explain further, let me re-enact the scene which took place during one of my presentations to a committee. It took place in the school library before the Assistant Principal, the yearbook adviser, ten parents and ten students. I brought mounted 16x20's, preview folios, wallet folios, 8x10's of our four finishes, price lists, and our giveaways. I had been the photographer at this school for fifteen years but was not there for the prior three years. Also presenting their programs were the incumbent studio, the two chain type out-of-towners, and three other local studios.

•Different groups involved with the school photographer will have different concerns and questions.

> "... photographers are
> not all created equal."

My presentation went as follows:

Let's begin today's lesson by letting you know who we are and where we are located and a little bit about our studio. I'm John Giolas. I own John Giolas Photographers. This is my thirty-ninth year of photographing school seniors in our area. It is what I have always done. It is what I lecture on to other photographers across the country. It is 40% of our total gross and above all, it is what I do best. Let me mention at this point that we have been doing the yearbook photography here at Maryville for the past twenty years with the exception of two years when someone else was chosen.

Now, contrary to what some folks think, photographers are not all created equal. Sure, we all use the same sort of equipment so our photos should look pretty much alike. Same film, same paper, same camera, etc. Right? Wrong! If I gave each of you the same camera and lights and the same subject and told you to bring back a picture of that particular subject tomorrow, you can be sure that we would have many different versions of our subject. Why? Because photographers are not all created equal.

The word photography is a Greek word which means to "write with light". Therein lies the key to my point. What you do with your lighting, how you "write with light" is one of the main decisions a photographer must reach. You must decide what kind of light source to use on that subject: reflector, umbrella, soft box, scrim lighting, spot lighting, parabolic etc. You must decide where to place each light and how many to use. You must also decide what angle to choose, what pose, what expression to seek. Finally, for today's senior, what backgrounds to offer. Today's senior is extremely visual-minded, constantly watching videos. You can't fool them with yesteryear's images.

By now, I'm sure you can see that a photograph doesn't just happen. It is created. That camera in the hands of a skilled photographer is just like the the brush in the hands of a talented artist. You are limited only by your imagination.

The Non-contractor

Photographers who choose the non-contractor route do quite well because:

1. They can charge more per package.

2. They can get a better sitting fee price.

3. They can take longer with each sitting.

4. They are working with people who chose them voluntarily.

5. They do not have to give the school anything… no percentage of his sales, no film, processing, or pictures.

6. They escape the cost of sending photographers to cover scheduled events.

7. They do not have to provide glossies of seniors.

8. The non-contract studio has a much better per sale average.

9. A much lower outlay of expenses relative to securing the business.

Most non-contractors do very well and they're proud that they don't pay one nickel to the school. Result: lower volume, higher averages.

How to Seek the Non-contract Work

Student Lists

First, you should get a list of the seniors from the area you wish to go after. A national list is not 100% accurate but nevertheless effective. A good source is the American Student List located in Great Neck, New York. Get the names by zip code. Get more than one set of mailing labels (at least three sets). It's cheaper to order all at the same time as opposed to later. Don't try to copy their list to save money, because they have trick names used to find out if you are cheating.

You can get a more personal list from a student that attends your target school. Find a student who is willing to copy the names of his or her classmates from the phone book. Pay .20 cents per name, (or whatever the rate may be in your area) and address. Some photographers get phone numbers too for telemarketing purposes. Remember it is illegal to have the student obtain the list from the school. This must be stressed. Student lists are usually 100% accurate.

Ambassadors

The use of ambassadors is a good idea. Early in April, get a few girls — pom poms, cheerleaders — and invite them in for a complimentary sitting. The whole idea is to get them to show your work to all their classmates. Give them discounts, complimentary pictures a credit of five dollars for each person they send in. You can have a pizza party, beach party or whatever for all the reps. The ambassador system can work very well for you and it can grow as each student begins to tell others about it. Eventually, you will have former ambassadors referring future ambassadors to you.

Brochures

On the basis of your list, you can send out mailings. These can be letters, brochures, coupons, and/or samples. Mail heavily and at least three times. Make your own brochures. Most labs have ready made brochures, with pictures already on them.

"The use of ambassadors is a good idea."

"... more people will see your work than in one year in your studio."

Letters

A letter can be full of information about your studio, prices, specials, an early bird special, coupons, reasons why they should come to you, etc. If you really want to play hard ball, you might offer to credit them with the amount of the sitting fee they paid the other studio. Be creative and innovative. Keep in mind your goal is to reach enough seniors and convince them that your place is "The place" to go for senior portraits.

Restaurant Displays

Try to get local restaurants to display a few 16x20's of local seniors. How about a McDonald's or a Dairy Queen, or some other hangout for high school seniors? Hook up with a local movie theater and get a display of your work put up in their lobby. Think of the exposure you will get. The local mall is a super place to display your samples, but it can be tough getting permission to do so. Imagine the numbers you're dealing with. In one day more people will see your work than in one year in your studio. Don't be discouraged in the beginning of your display campaign if nothing much develops. Keep it up. It's seed planting for future cultivation. It has always worked for me and it will work for you.

Chapter Two

Lighting

We begin this chapter by assuming you already have the necessary equipment and general fundamentals needed to photograph high school seniors. As we go into this lighting guide, it is important for you to understand my lighting motto — *keep it simple*.

The Standard Four Light Set Up

Learn to use your lights with the standard four light set up — main, fill, hair and background lights. Use them often. Use them the same way every time until you know exactly what they are capable of doing in the situations in which you will be using them.

Once you are capable of coming in with consistently good exposures, then and only then should you do some experimenting. Concentrate on the basic rules of lighting. Learn to see light. Be totally aware what your lights can do for you. Once you do that, the camera in your hands can be every bit as creative as the brush in the hands of a talented painter. You will be limited only by your imagination.

The Main Light

There should only be one basic source of light — the main light. For the main light, you can use a parabolic light with a sixteen inch reflector or a medium soft box light. A parabolic light is a direct light giving you sharper lighting with clearly defined shadows. A soft box is a light bounced inside a translucent box, which gives you soft, forgiving wrap around lighting, through a translucent front panel.

The main light is usually used about 45° to one side of the camera. The distance of this light is usually anywhere from five to six feet from the subject's face, depending upon the power of your flash unit and size of reflector or soft box being used. A good rule of thumb relative to where to position this main light is to look for the catch lights in the subject's eyes. Those catch lights should appear at ten or eleven o'clock, or at one or two o'clock, depending on what side you are lighting from. I personally prefer the 10 o'clock and 2 o'clock scenario.

"Learn to use your lights with the standard four light set up…"

The Fill Light

The fill light does just as its name implies, it fills in the harsh shadows that the main light will create. If the fill is used correctly, you will not know it was involved. At least your customers won't. The fill light enhances but does not destroy the modeling the main light has created. The fill should be a larger light source than the main. We use an umbrella as a fill light. Light is bounced into an umbrella giving you a non-directional light with a broad lighting pattern. This light is set up close to the camera, and as close to the lens as possible.

The 3 to 1 light ratio. The main light only illuminates the highlight or brighter side of the face — it does not illuminate the shadow side of the face. On the other hand, the fill light does illuminate everything that the camera sees. Therefore, the light ratio is expressed numerically in terms of the total amount of light falling upon the highlight side relative to the shadow side. The light ratio you should strive for is 3 to 1.

To achieve this ratio, place the fill light one f stop larger than the main light. Another way is if the main reads f11, place the fill so it will read f8. Or assuming you will use two lights of the same power, if you place the main light five and one half feet from the subject, then place the fill light eight feet from the subject. You will have a 3 to 1 ratio. Some photographers like to put some diffusion over the fill light, giving it a softer shadow line.

If your meter won't work. Guide numbers can help if your light meter stops working. You should know the guide number of your flash unit relative to the film you are using. Divide the feet your flash is from the subject into your guide number and you will have your desired f stop for your flash and that film.

The Hair Light

The hair light is also used for enhancing the main light. Place this light on a stand with a boom approximately five feet above the head and behind the subject. This light should be set up so it does not illuminate the forehead.

The idea is to merely skim the hair, rather than pounce on it. Use a five inch reflector with a snoot for this light. A snoot produces a small circle of light.

The Background Light

This is another light that enhances the main light. Basically, this is a small light with a five inch reflector used between the subject and the background and aimed at the background. It primarily serves as a separation light, giving the background some depth.

The background for bust type portraits should be about five feet from the subject, which allows you to put the background light between the subject and the background.

With the use of a gel over your background light, you can alter the color of the background. A gel is a piece of heat-resistant transparent plastic material that comes in sheets of many colors. This gives you a way to color coordinate the background with what the subject is wearing.

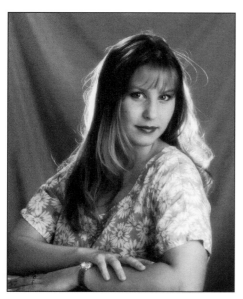

2-1: An example of back lighting on the hair.

Basic Lighting Techniques

There are various lighting techniques using this standard four light set up. Some of the most important ones are as follows:

1. Broad Lighting.

2. Short Lighting.

3. Butterfly Lighting.

4. Profile Lighting

5. Rembrandt Lighting.

6. Split Lighting.

Broad Lighting

The side of the face turned toward the camera is fully illuminated. If your subject is seated with the face looking away from the main light, this is broad lighting. The shadow falls on the side farthest from the camera.

Short Lighting

This is my favorite type of lighting. The side of the face turned away from the camera is fully illuminated. The side closest to the camera is the shadow side.

Butterfly Lighting

The main light is placed directly over the camera lens at the same height as you place any of the other lighting. The shadow you see under the nose resembles the shape of a butterfly, giving it its name: the butterfly light. Please note that the shadow should not go into the lip line.

Profile Lighting

The body is facing full front or full back while the subject's head is turned so the face is looking off to one side. You can use a front profile or a back profile.

The main light is positioned at about the subject's nose causing a shadow on the side of the face facing the camera. The main light should still be the same distance from the camera as the rest of the shots. You want to get a triangle of light on the cheek facing the camera. When doing profiles, they should be just that — a full profile. Remember the Giolas rhyme: where the nose goes the main light goes.

A good tip here is for you to make sure no part of the other eye is visible, other than maybe an eyelash.

Rembrandt Lighting

Named after the old master painter, this lighting is a variation of the short lighting and the butterfly. The main light is placed on the side of the face turned away from the camera. I look for a triangle of highlight on the subject's cheek away from the main light. When done well, it presents an elegant portrait.

2-2: An example of profile lighting.

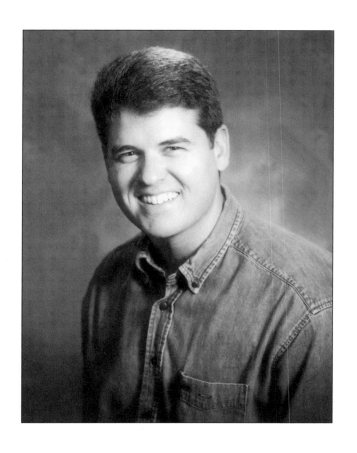

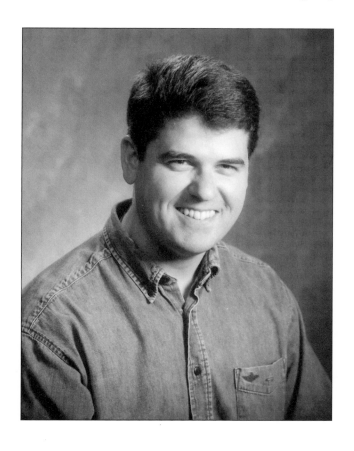

2-3 (upper left): Broad lighting.

2-4 (upper right): Short lighting.

2-5 (lower left): Butterfly lighting.

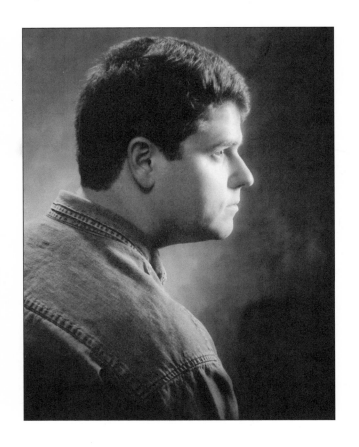

2-6 (upper left): Profile lighting.

2-7 (upper right): Rembrandt lighting.

2-8 (lower right): Split lighting.

Split Lighting

The main light illuminates one side of the face only, leaving the other side in shadow. This is not an easy lighting to master.

Lighting in My Camera Room

The camera room, which is 20x24 feet, is set up so you can shoot both full length and busts without moving any lights. Full lengths are shot on one side and bust type shots on the other. In the chapter on Photographing Seniors, I will explain how we take advantage of every nook and cranny of that room.

The Full Length Side.

All poses from muslin area through and including the high key area are taken using the lighting set up shown on page 19.

The main light is one sixteen inch parabolic on a stand approximately seven to eight feet from the subject. This light is diffused a bit. (Diffusion over your light gives you softer shadows with broader coverage and slightly less contrast). Set that light up to get an $f11$ reading so you can stay within the 3 to 1 lighting ratio. The cords to all of these lights are hung from the ceiling.

The fill light is produced by two forty-two inch umbrellas which are positioned on each side of the camera, ten feet from the subject. They are hung from the ceiling with picture hanging wire. They give me an $f8$ reading and, since they are a fixed fill (I never move them), the meter reading for the fill light is always the same.

> "The cords to all of these lights are hung from the ceiling."

2-9: *One of two umbrellas hung from the ceiling on the full length side of the camera room. The umbrellas are used as the fill light.*

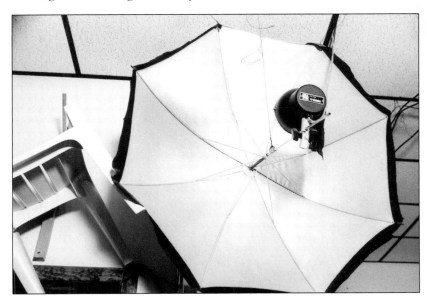

Background lights are two Flashmaster lights positioned on the floor, one on each side of the background. These serve as background lights on the hi-key shots. High-key means that your background is basically all white. To achieve this effect, you blast the white seamless background with approximately four times the light that you are using on your subject. There should be no horizon line on these shots.

Bust Area Lighting Set Up

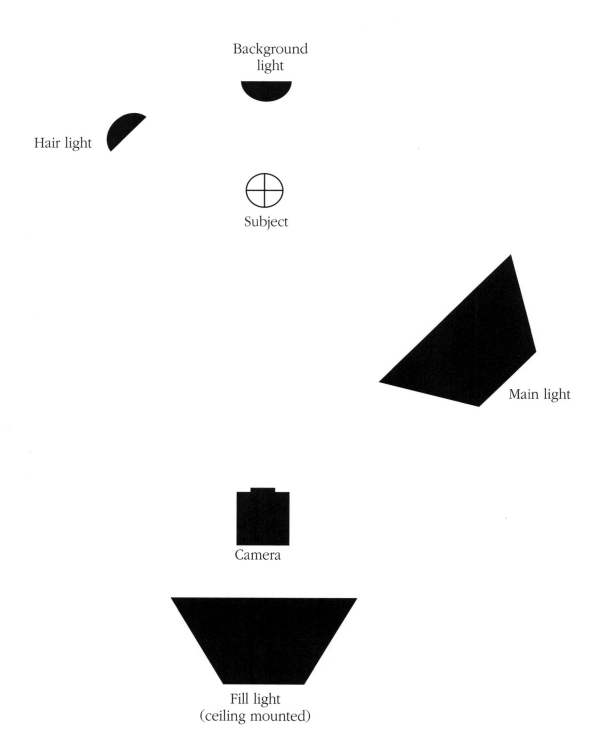

Background light

Hair light

Subject

Main light

Camera

Fill light
(ceiling mounted)

Full Length Area Lighting Set Up

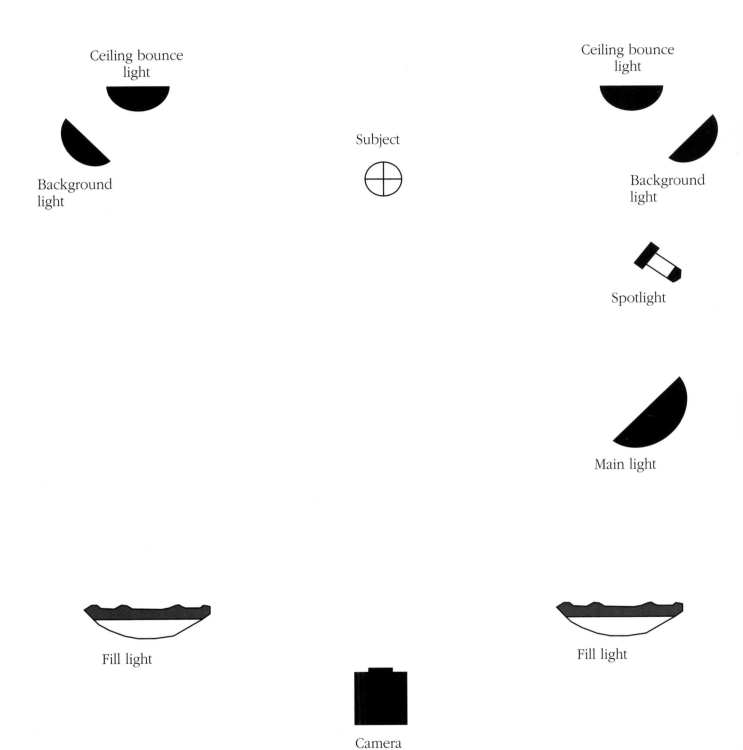

2-10: An example of a high key portrait taken in the full length area of the camera room.

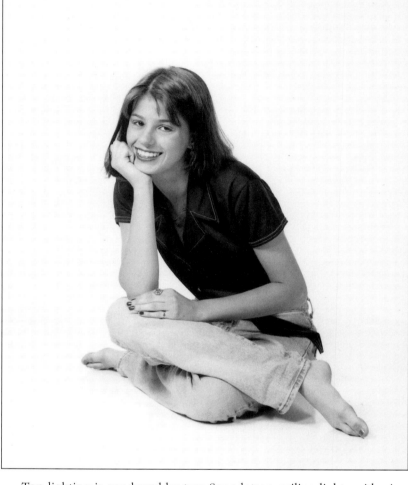

•**Cookies are metal cut-outs which are inserted into the spotlight. You can create a variety of patterns on the background and spice up your photographs.**

Top lighting is produced by two Speedotron ceiling lights with nine inch reflectors. These lights are bounced off of the ceiling to provide separation and hair lighting for our full length portraits.

The background for most of our full length shots always includes a pattern created by the use of our spotlight with various cookies inserted. Cookies are metal cut-outs which, when inserted into the spotlight, make patterns on the background. These patterns will certainly spice up your photographs. Cookies can be purchased from the makers of spotlights or you can cut them out yourself.

The Bust Side

All portraits taken from the yearbook pose on up to and including the graffiti wall are taken using the lighting set up shown on page 18. (We do not use the hair light or the background light on the graffiti pictures.)

The main light is a Lite dome medium soft box on a light stand.

The fill light is a Lite dome large XTC soft box hung from the ceiling facing the bust side.

A hair light is used with a five inch reflector and a snoot on a stand with a boom. A snoot is an attachment that fits over the reflector making it a small circle of light when it lights the subject's hair.

2-11: This is the bust side of the camera room. Note the fabrics, the shade holder and the pyle panels.

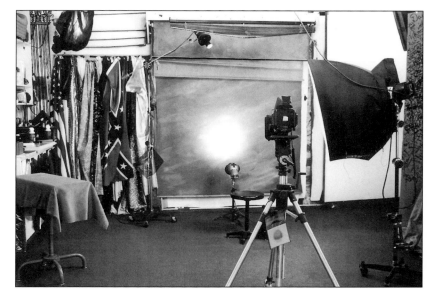

A background light is used with a five inch reflector and a grid. A grid is an attachment which serves the same purpose as a snoot but with softer edges.

In the bust area, a large XTC Lite dome soft box hung from the ceiling serves as the fill light with an ƒ8 reading. The main light is a medium soft box on a light stand positioned so that it will give a reading of ƒ11, the result being a 3 to 1 lighting ratio. The cords to all of these lights are hung on the ceiling.

All of the mains, fills, hair and background lights are triggered by a radio device on the camera. A radio device is a triggering mechanism plugged into the shutter, tuned to a radio frequency picked up by a receiver in the camera room. Any other accent lights, such as high-key background lights, full length ceiling bounce lights, and the spotlight are all fired by photo slaves (a.k.a. photo cells). A photo slave is a plug-in device that can be attached to any power pack, thereby firing any flash head it is connected to.

Since we are primarily senior photographers and because all of the senior portraits are taken in the studio, we need to have the lights and cords up and out of my way in order to move 1500 seniors through there with a minimal amount of light stands to move and no cords on the floor. This camera room was designed so that we could do as many students as I could personally shoot and still put out a quality product with as much variety as could be brought into each sitting. The secret to consistent quality is a minimal amount of light movement.

"The secret to consistent quality is a minimal amount of light movement."

CHAPTER THREE

The Studio Set-Up

The following describes how we photograph approximately 1400 to 1600 seniors from June to November. The only way this can be done with only one photographer in a rather small room is to organize the route which every senior will take. The room has to be set up so there will be a minimal amount of moving lights, cameras, and props. This means that, as we go into each nook and cranny of the camera room, a background awaits with the necessary lighting in place.

It is an assembly line set-up, but it must **not** look as if you are working in an assembly line atmosphere. As each area of the session is described, I will include sketches or photographs of what the area looks like. This chapter will be organized as if I was giving you an imaginary tour of an efficient studio set up.

Note that the backgrounds discussed in this chapter are presented in greater detail in Chapter Five.

The Senior Bust Type Portrait

When high school seniors enter the camera room, they immediately begins to feel comfortable as they hear the kind of music they like playing on our stereo. If you choose your music right, it will go a long way in putting you on the right side of that senior. The mom has been seated — we like it when the mom is in there with us — and the senior is ready for the session to begin.

The first stop is the area for senior bust type photographs, although here you can also photograph many other types of poses. The senior starts here with the yearbook pose, and can stay in this area if you feel the senior is wearing the appropriate attire for some additional shots. Additional shots are possible because there are four pull down canvas shades to use as well as the wall directly behind the subject. The shades are hung on the wall with the use of a home-made holder.

In addition to these options, there are a few more backgrounds on that wall just behind those shades. The backgrounds are made of foam core boards which are covered with various kinds of crinkled foils. We

"...organize the route which every senior will take."

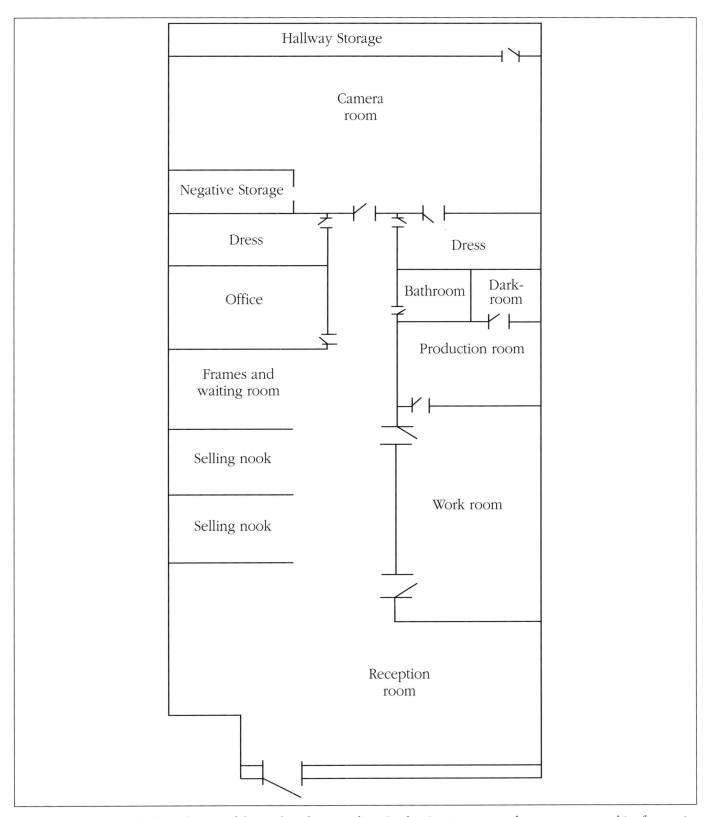

This diagram shows the basic layout of the Giolas Photographers Studio. It is important that you use every bit of space in your studio wisely and efficiently — especially with the volume of seniors that will be coming for their sittings.

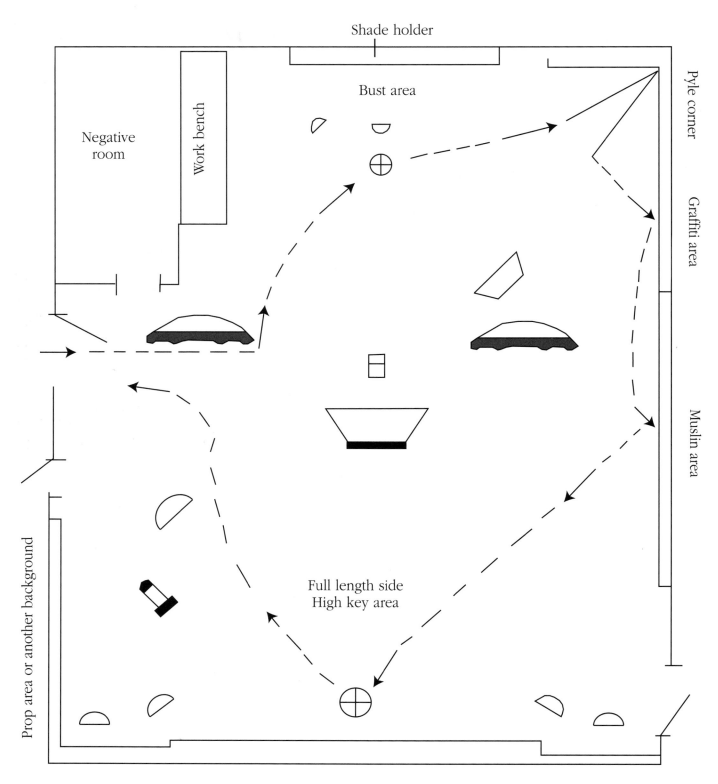

The first stop is the Bust Area. Then we go to the Pyle Corner. After that, we move along to the Graffiti set up. We follow this by going into our Muslin Area. Now we are ready for the full length side of our studio. Here we do all of our high key photography with our special effects. In this area, we also take full advantage of the spotlight, and most of our props.

3-1: A typical senior portrait taken in the bust area of the camera room.

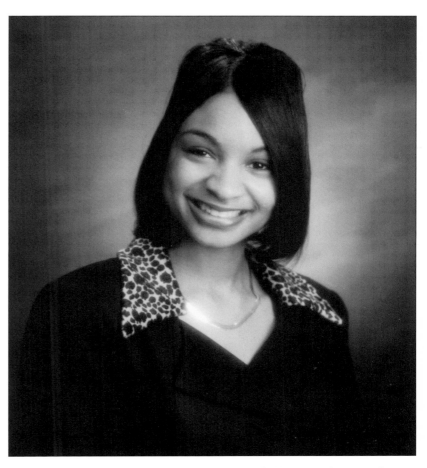

get our sheets of boards from Fomebords of Chicago. They can be cut into pieces of about 5x5 feet and hung on a nail with the use of picture hanging wire. By placing a gel on your background light, you can create very interesting patterns as the light bounces in and out of the crinkled foil.

Fabrics can also be used as backgrounds. In our studio, these are found on the wall to the left of the above mentioned backgrounds. The fabric backgrounds give you even more options.

For the equipment used in the areas so far described, we use the RB camera with a 180mm lens on a tripod. For the rest of the sitting, we will use a camera stand which has an RB camera with a 127mm lens.

The Pyle Corner

Just to the right of the area we have just described is a background which resembles those swinging racks they have in lumber display stores which are used to display various 4x8 panels. What you use on those panels is up to you. You can use a brick pattern, a stuccoed pattern, and a black vinyl home-made effect on another.

The Graffiti Wall Area

When a senior reaches this area, he will see a background of foam core board that has his classmates' signatures on it. Hand the senior a

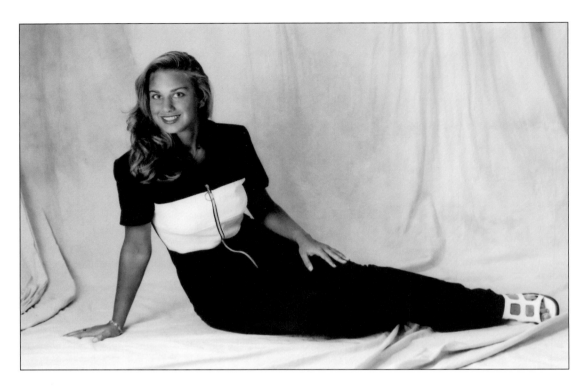

3-2 and 3-3: Examples of senior portraits taken on the full length side of the camera room. A muslin background was used in both photos.

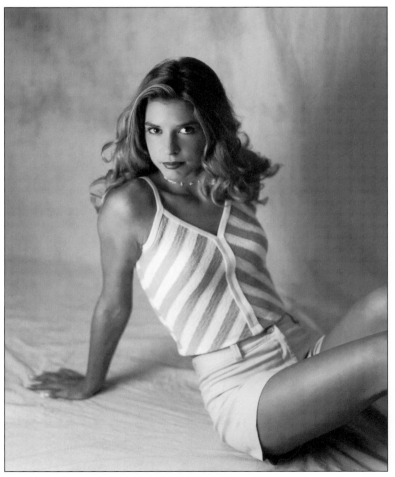

felt marker and ask him to sign his name on the graffiti wall, then take a photograph.

The Muslin Area

Next to the graffiti area are two long muslin backgrounds. One muslin is ivory painter's cloth and the other is blue. What the senior is wearing governs your decision as to which muslin will be used.

In this setting, you can do full lengths, sitting down poses, and reclining type poses. These muslins are easy to pull in and out of the way, since everything that is done has to be quick and easy and still look well done.

We love it when the students or even the mom say they can't believe how we can create so many beautiful backgrounds in such a relatively small room.

Before we leave the muslin area, this is the place we use most when seniors bring their own props with them. We encourage everyone to bring their own props — basketballs, baseballs, bats, soccer balls, cycles, rifles, guitars, drums, pets, stuffed animals, whatever. You bring it, we shoot it. In this muslin area, we do some of our most creative work.

Full Lengths

Now we make another right turn and we find ourselves in our full length shooting area, which is located opposite the short shooting side of our camera room. In this area, we do our high key portraits.

When the last shots have been taken on this full length side of our studio, it usually means the end of that person's sitting, and the beginning of the next person's. This is how it goes all day long. Although you may feel that all of the decisions have been made, you still are confronted with which backgrounds, which props and which gels to use plus a few other decisions to make at every stop.

It should be mentioned that while we are doing all this photography, we are working with one student in the camera room, plus one student in each of the three dressing rooms. There must be a constant supply of seniors so that while one is changing, we are already working on the next senior.

"... everything that is done has to be quick and easy ..."

CHAPTER FOUR

How to Pose Seniors

This chapter will look at the various poses you can use for seniors. From the basic bust type yearbook portrait to three quarter poses and finally to full lengths, basic posing ideas will be discussed. You can then use these basic ideas to create even more posing options.

It should be noted that, as you work with each individual senior, you will find that some lend themselves to certain poses more than others. Take advantage of those that do and you will come up with unique and effective poses. For those you realize are not as comfortable with doing some of the poses, stay with the basic, easier poses.

A word of caution: experience tells me that when someone chooses your high end sitting package, he wants the works. Do not skip a pose because you think it won't work well for that subject. Do it anyway. Most of your senior subjects will love to play "model" for a day.

The Bust Type Pose

No matter how many new poses have been introduced throughout my forty years of photographing seniors, the tried and tested, good old head and shoulders pose is still by far the most popular pose. It is the pose most ordered. It is the pose that continues to bring in the most sales. It is also the only pose the yearbook adviser will accept for the senior portrait section which is another reason why you should learn to do this pose well.

Posing the Bust Type Yearbook Portrait

Place your adjustable stool about four to five feet from your background. Learn to adjust the stool height at or about the knees of the subject which will help you place the head at the desired height.

To insure that the head size will be the same on the negative for all of the seniors, mark the desired head size on the camera viewer. Advisers will love this since they win awards on consistency of head sizes in their senior sections. Then try to keep all of the heads within those lines.

"It is the pose that continues to bring in the most sales."

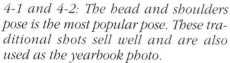

4-1 and 4-2: The head and shoulders pose is the most popular pose. These traditional shots sell well and are also used as the yearbook photo.

Make sure the hair is the way the subject wants it. If there is a question about it, have the senior go back into the dressing room. How he or she leaves that dressing room is what he or she will get in the final portrait. This needs to be stressed to both the senior and the mother.

Regarding glasses, it must be explained in your price list that it would be a good idea if the senior could get a spare set of frames, without the lenses, to use for the sitting. Although you will do your best to minimize glass glare, some prescription lenses will reflect no matter what you do.

Posing Senior Boys

On a 20 exposure sitting we take 8 senior bust type poses. The first 3 shots are with the shoulders turned toward the main light. Take one looking at camera, one looking off camera right and one looking off camera left. On the second three exposures, turn the subject away from the camera and repeat the procedure. What you have done is photographed the subject with both short lighting and broad lighting. For the remaining two (or however many you feel you need), you can lean the subject in toward the camera slightly dipping the front shoulder. Do this from both sides. Those are your basic yearbook poses that will be acceptable for the yearbook and most parents.

When posing senior boys, learn to look at the way the suit is laying and make sure that there is no gap between the suit collar and the subject's neck. If needed straighten the tie. Watch out for shirt collars that might not be properly arranged. Make sure the jacket has not pulled away from the shirt collar. A good way to insure that this will not occur

is to take hold of the front of the jacket right at the front top button while he is standing, and then ask him to sit as you hold on and pull down on that front area of the coat.

Now is a good time to check for lint; use a lint brush if needed. On women we have wrinkles in the clothing (not acceptable), however, on men we call them folds. Folds are allowed, and we can arrange them to our liking. Look at the collar for abnormalities. Sometimes boys will come in with a shirt that is too big. Here is a little trick for a kid that comes in with a shirt collar way too big. Nip in the back with a clothes pin or any clamp. Now you have instant collar correction. Straighten the tie, even if it does not need it. This makes you look knowledgeable and proves you are concerned.

I have my own way of posing men who are wearing double breasted suits. Ask them to unbutton the jacket, then sit them down. Now arrange the coat in double breasted fashion and have the guy put his finger or hand right where the button would be.

The moral in all of this is you really have to look beyond the lighting. Learn to look through the subjecy: at his clothing, the background, and everything that is involved in the final result. Do it with haste, if you wish, but do it.

Posing Senior Girls

Relative to adjusting the stool and preparing to do a senior yearbook sitting of a girl, nothing really changes. However, now you must really be cognizant of her hair.

You will run into a lot of disagreement on hair between mom and daughter. Stay out of it but make it clear that what you see now is what you will get later.

Look for the proper alignment of any jewelry. Make sure jewelry is centered from the camera angle. Look for any flat pieces that may cause a reflection problem.

The poses for the senior girls are the same as the boys except for the last two poses. You can do one over-the-shoulder pose from each side. Make sure you do not shoot into the shoulder.

By staying in the bust area, you can come up with a variety of poses by changing the background with the use of the canvas shades, fabrics and by putting a colored gel on your background light. The posing table (an adjustable table or arm rest covered with cloth) is used in this next series of shots.

Hand Poses for Boys.

1. Have the boy put both hands on the table. The picture should be cropped just below the hands showing part of the table. You can use the looking at camera and off camera approach on these shots. Turning the head into a 3/4 face view makes a very saleable portrait.

2. Place his thumb under his chin and his first finger on the chin. You can lean him into the direction of the main light looking away from camera. If leaning and looking left,

•**Be cognizant of a girl's hair and remind her that what she sees now is what she'll get in the photos.**

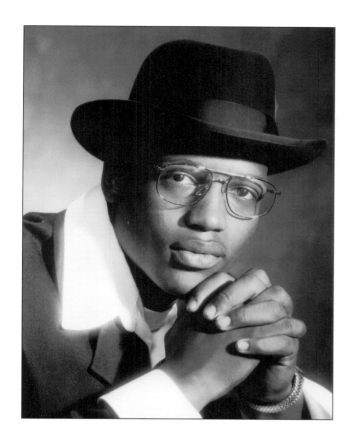

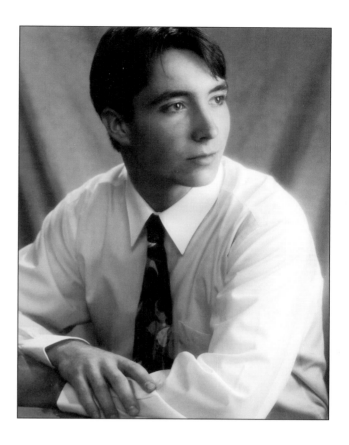

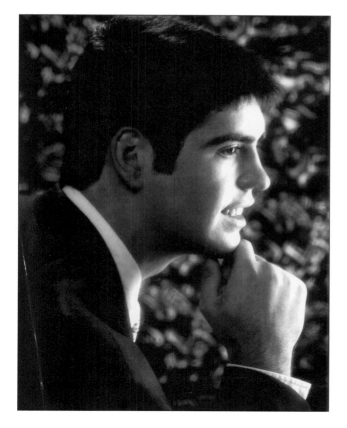

4-3, 4-4 and 4-5: A variety of hand poses can be used for boys. Here are three examples.

4-6: Another example of a hand pose for a boy.

use the left hand. Note: when you do any shots looking off camera, give the subject something to focus on.

3. With elbows on the posing table, ask the senior to interlock both hands and place them just above his chin with head facing the camera.

4. Profiles. Profiles can be done with or without the hand. For a front profile lower the posing table so that the senior will have to lean down a little to place his elbow on the table. This will force the senior to have to lean down to get his hand on his chin. Always use the hand furthest from camera when posing this shot. For the back profile hand pose, always use the hand closest to camera.

More Poses in This Area for Boys

1. While the boy is seated, ask him to put the leg closest to the camera on anything that will get that knee up higher than the other one. You can use a short box, block of wood, etc Now place the elbow on his knee as he leans in a bit.

2. Still in this position ask the boy to place the knee furthest from thecamera on the box, then place his elbow

Left: This three quarter length photo was taken in the pyle corner using the folding arms pose.

Right: This hand pose was taken using the posing table and fabric background.

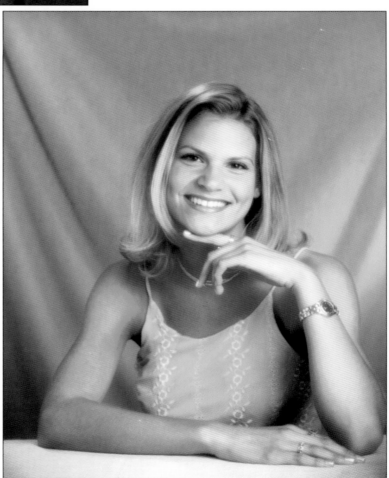

Right: A full length shot using a muslin back-ground and pillar as a prop.

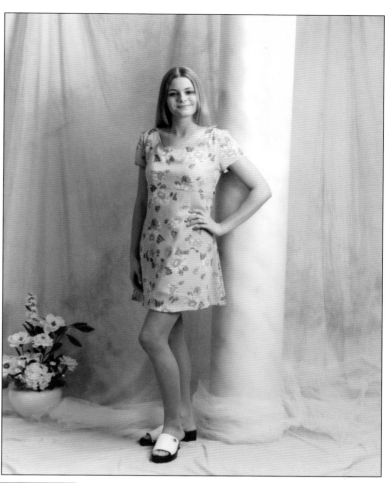

Left: Another pose using the muslin background in the full length area of the camera room.

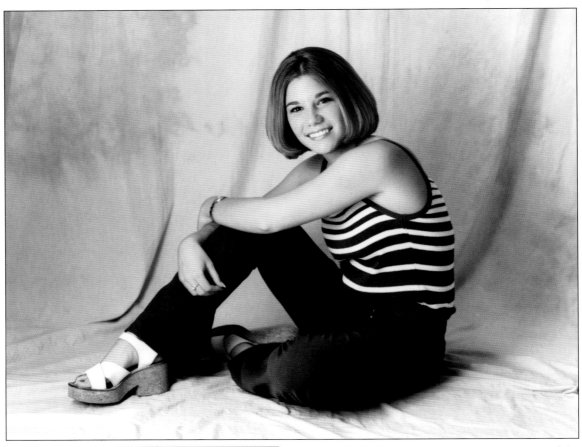

Above: A casual pose in the full length area of the camera room. The muslin background was used.

Left: A three quarter length pose using the pillar and a vase as props.

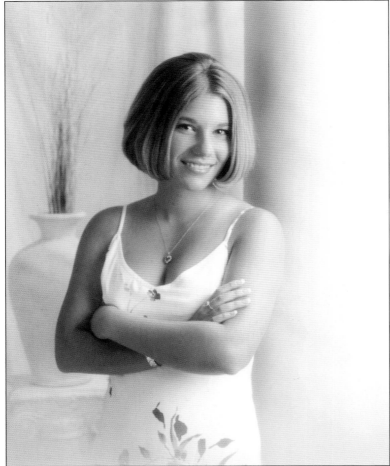

on that knee. This will lean him back a bit. Note: both of these poses are cropped just below the knees (three quarter length poses).

3. Place both hands on the table. Have the posing table run at a slight angle from camera. By changing the position of the face and the area in which the subject is looking, you can easily vary each shot.

4. By using only the edge of the posing table, you can have the subject lean his elbow on it with wrist bent so it joins up with the other hand.

Hand Poses for Girls

Hand poses for senior girls offers you a chance to be much more creative as opposed to senior boys. You can use more variety on lighting and backgrounds as well. Since there are so many variations, we will expound on only the standards.

1. Place both hands on the table and do the normal at camera and off camera routine. Place the hands and arms properly. In this series, try one shot with the subject looking and leaning down away from the camera and having the eyes looking at the camera.

• **Hand poses for senior girls can be much more creative than those for senior boys.**

4-7: Here's an example of a hand pose. Come in close on some shots whenever the subject warrants it.

4-8, 4-9 and 4-10: There are a variety of hand poses you can use for senior girls. Here are three examples.

2. Take one hand and, with the elbow on the table, place the fingers just below the chin, making sure you bend the wrist just a little. The first finger is touching the chin as the rest of the fingers curl down. Use the adjustable table to do this so that the elbow stays on the table, as the fingers reach for the chin.

3. You can vary this basic set up by placing the girl's chin in her cupped hand, or even use both hands, fingers interlocked under the chin.

4. Any of the above hand poses can be altered by using back lighting on the hair. Turn the background light around so that it is aimed at the subject's hair. You can further enhance this pose with the use of a gel on the background light. You must choose someone who has full hair to be able to look good with this light set up.

5. Coming in very tight is another option for some girls, especially on the backlit hair poses.

6. Back profiles with the hand on the shoulder and the eyes looking down, with or without diffusion, is a nice pose. Note: with the use of fabrics, foambord covered backgrounds, and gels over the background light, you can create a lot of different looks, without leaving this area.

More Poses in This Area for Girls

1. Over the shoulder poses are done by having the girl place her arm closest to the camera on her knee or a lowered posing table. This creates a nice line over which the chin will go naturally. Do this on both sides, if you wish. Also remember that you can backlight her hair, if she has long hair, and even gel the background light.

2. Profile poses with all of your background options are a very nice addition to your sittings. Do a front profile making sure it is a true profile. Remember: "Where the nose goes the main light goes." Do a back profile. Be sure the subject's back is perpendicular to the camera. Use profile lighting.

•Every pose can be altered to create a wider variety of options for you and your clients.

By tilting the head of your subject up or down you can easily change the picture. You can tilt the camera to create additional variations of these same poses.

The Three Quarter Length Poses

Three quarter length views are usually poses which are cropped at between the waist and knees.

Using the Pyle Area

When posing boys, have them stand in front of any background that will allow you to get a three quarter length without shooting off of the

4-11: *This photo uses the brick background found in the pyle corner of the camera room.*

background. Posing options are many, such as arms folded, hands in pockets, etc. If it is a brick wall, such as ours, simply have him lean on it.

A word about posing people with their arms folded. I don't know why, but most people have their own way of folding their arms. And if you try to have them re-arrange which arm goes under the arm and which one goes over, they simply can't do it any other way but the way they do it comfortably. My only insistence is that one hand goes under the arm and one hand goes over. Avoid the look you get when both sets of fingers are showing.

When posing girls in the pyle area, we use the ebony background. We pose the girls with their hands folded. In this area, we come in a little closer than we do on most other three quarter length views. We also use the brick background and pose the girls much like the boys.

You may choose any panel design you wish for these three quarter length poses. We use a stucco pattern that works well. Hands in pockets, hands on hips, hands folded, or hands touching the wall are just a few of the poses that you can employ.

Using the Graffiti Area

In this area, you can choose to pose using a three quarter length standing view or a three quarter length sitting view. We pose our boys

4-12: An example of a pose used in the graffiti area.

and girls on our three-tiered posing bench, which is covered with a piece of blue muslin. Remember to have the subject sign the graffiti wall and make sure the year is visible in the background.

To pose a boy in this area, ask him to sit on the posing bench with the leg furthest from the camera on the higher step. Or, if you are using a stool, have him place his leg furthest from the camera on the elevated box. Next ask him to put his elbow on that leg and put his other hand on his hip. You may also have the leg closest to the camera on the higher step, and have him place his elbow or arm on that knee.

For posing a girl, have the knee furthest from the camera on the higher step. Now ask her to put her elbow on that knee and bring her hand up to her face. Her other hand is placed on the same step on which she is sitting.

You may vary this pose by having her cross her knees, turn her shoulders slightly, and place both hands next to her, one on each side of her. Naturally, you can create a few more poses in this graffiti area.

The Full Length Poses

In the muslin area, you can do your most creative posing. You will use a variety of poses which will include the three quarter length, full-length, standing, sitting, and lying down poses. You can use many of the following poses in the high key area as well.

"In the muslin area, you can do your most creative posing."

Casual posing for boys

1. Full-length standing. For standing poses always make sure the boy is standing with his feet slightly apart and his body turned just a little. This is your basic pose. What you do from now on depends on how he is dressed. If he is in a suit have him put one hand in his pocket. If he is casually dressed you may ask him to put both hands in his pockets, or have him put his thumbs in his pockets, or if he has brought some of his own props, such as a golf club, a bat or in the other prop make sure you use them..

2. Kneeling. You can use the standard pose of having him place one knee on the floor and the foot on the floor as he places his arm on the knee that is raised. You can alter this pose somewhat by a having him sit in a squatting position.

3. Sitting on the floor. I have found that on many of the poses, especially for the boys, it is a good idea for you to get into that pose to show them how you would like it to look. Have the boy sit on the floor and as he lifts

4-13: An example of a casual male pose in the full length area of the camera room using the muslin background.

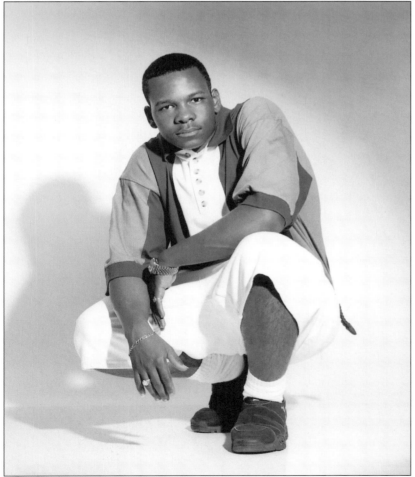

4-14 (above): Here's a photo that was taken in the full length area using the muslin background. This area is where you can do your most creative posing.

4-15 (left): Be creative with your poses. Also remember that some subjects look better in certain poses than others. This is an example of yet another senior male pose in the full length area.

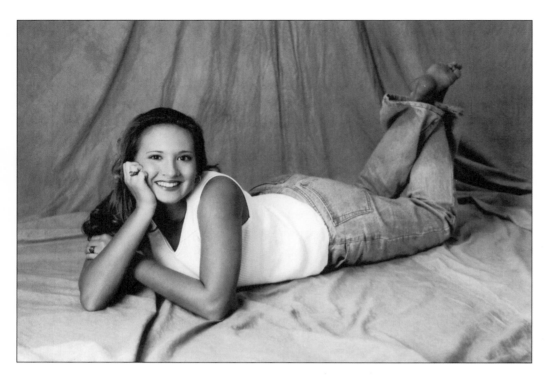

4-16 and 4-17: Here are two examples of casual poses for girls. Both photos were taken in the full length area of the camera room using the muslin background. You can pose the subject laying down (above), sitting (right), or a variety of other ways. The muslin area provides so many posing choices, both for formal and casual shots.

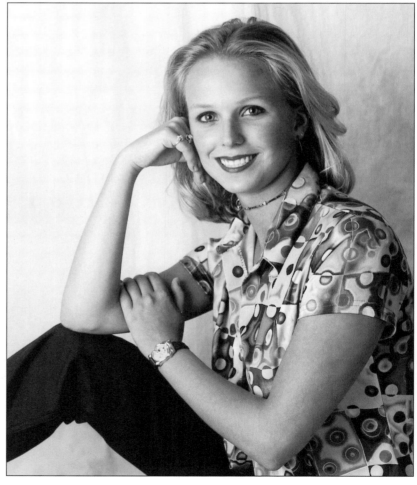

one knee, put the other leg underneath that knee. Place his hand on the raised knee and put his other hand on the floor.

4. Lying down poses. While the guy is in the pose just described, have him lay on the floor on his side and ask him to put his elbow on the floor and place his hands together in front of him. Now make sure his head is straight as you zoom in very tight for this pose. Needless to say, your camera should be as low as you can get it to be on the same level as the subject's head.

Casual Posing for Girls

1. Standing. Always start with the basic number one modeling pose. Use your own props, and be aware of the props they have brought in. More full-length poses can be used in the high key area.

2. Sitting on the floor. There are many, many ways to photograph a girl sitting on the floor. For starters, have the girl sit on the floor with her knees pulled up close to her body and her head tilted towards her knees. Now ask her to lower the knee closest to the camera just a bit as she places her elbow on the knee that is higher. The hand that is closest to the camera is placed on the floor behind her, and the hand on her knee touches the face.

3. While the girl is in this position, ask her to the lean toward the camera with her knees still bent as she sits

4-18: Posing options are almost limitless when using the muslin background.

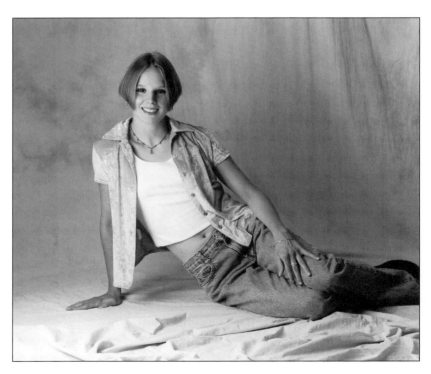

4-19: This is a very nice pose to use when photographing a senior girl. Again, a muslin background was used in the full length side of the camera room.

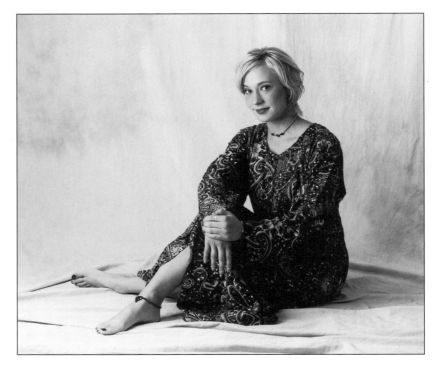

more on her thighs than on her backside. One hand goes on the floor and the other hand rests on her thigh.

4. Lying down on the floor pose. While the girl is in the above pose, ask her to lay on her side and place her elbow on the floor. Now place her hand on her face with the other hand on her thigh. Make sure the knees are bent slightly.

5. While the girl is in the above position, come in tight and do a close-up of her. You can vary this pose by merely taking away the hand on the face.

6. In this next pose, ask the girl to lie on her stomach with her elbows in front of her. She can place her head in the palms of her hand or fold her arms or read a book. For this pose, you must angle the body slightly with the feet being further from camera than the head. (As you look at some of the pictures in this book, you'll find variations of some of these poses.)

CHAPTER FIVE

Backgrounds

In Chapter Three, a brief discussion of various backgrounds was presented on our imaginary tour of a studio. In this chapter, we'll take a more in-depth look at many of the background options you can have when photographing high school seniors. By having a lot of backgrounds available, you give clients more options which will help to maximize your sales.

Backgrounds for the Bust Type Portrait

As you recall, the first stop the senior makes is the area for senior bust type photographs, although here you can also photograph many other types of poses. This is possible because you can have pull down canvas shades to use as well as the wall directly behind the subject.

The shades are hung on the wall with the use of a home-made holder. Made of wood, this holder measures 6x1 feet and is fastened directly to the wall. The canvases are on staggered shade rollers and affixed with the usual shade holding hardware.

Foam Core Backgrounds

These come in 4x8 foot sheets and can be easily cut to any size needed. We cut ours down to 5 feet. They are hung in stacks just behind the canvas shades, so that when all the shades are up you are ready to work with foambords.

To make a foamcore bust-type background, order a roll gold foil paper or gold metallic Mylar from a prop company. We use Studio Specialties located in Chicago. These foils, papers and vinyls come in rolls of various widths, from 42 to 60 inches. Spray adhesive on one side of the cut-to-size foam core board. Now take the gold Mylar and scrunch it up as you begin to fasten it to the foam core board. Or, you may use a staple gun to put the folds and crinkles exactly where you want them. Depending on what size boards you use, you may choose to focus in very tight on these poses. This allows you to use a smaller board which saves a little wear and tear on the photographer.

> "...you give clients more options which will help to maximize your sales."

5-1 and 5-2: The metalic fabric serves as an interesting background.

By placing a gel on your background, you will create a very interesting pattern, as the light bounces in and out of those scrunches you designed.

Fabrics

Fabric backgrounds are pieces of material 42 to 48 inches in width and approximately seven feet long. You can get these at any fabric store. By checking the sale table, you can get some great buys on remnants. In our camera room, there are approximately thirty different fabrics on the rack to choose from, as you search for what would be an appropriate background for that subject.

Believe it or not, you can use these fabrics as backgrounds on boys as well as girls. You can find almost any pattern you want at any fabric store or department store.

To get the fabrics ready to use, staple a piece of velcro on each end of the cloth. Then staple a long piece of velcro all along the wooden strip on the bottom of one of your canvas shades. As needed, affix the fabric to the velcro on the shade, creating yet another background.

Store these fabrics by fastening a 1x4x8 foot piece of wood to a wall in your camera room, as close as you can to the bust shooting area. Now staple a row or two of velcro on the entire length of the board. The

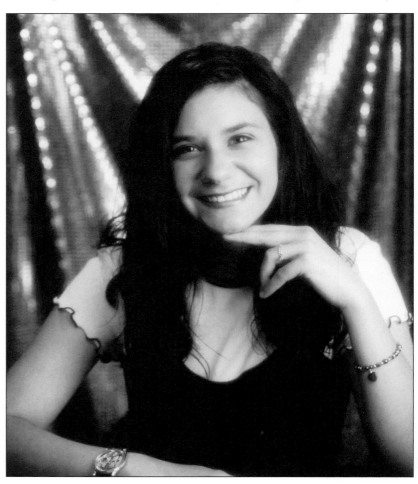

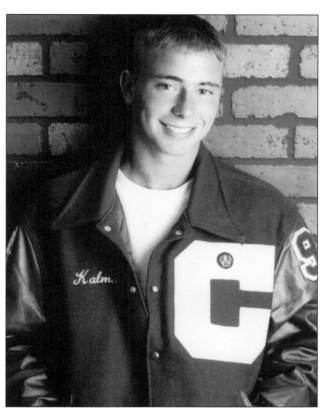

5-3 and 5-4: A brick panel used in the pyle corner also makes for an interesting background.

fabrics are hung by attaching the velcroed corners on the cloth to the strips of velcro on the wall.

Mini Blinds Background

This background is on a pulley and raised up out of the way until we need it to become a background. These mini blinds are reversible, white on one side, black on the other. By using the black side of the mini blind and a dark background and placing a red gel over your background light, you can come up with some stunning effects. You may also use the white side of the blinds, giving you even more options.

The Pyle Background

This background resembles those swinging racks they have in lumber display stores which are used to display their various 4x8 foot panels. This gives you another four backgrounds merely by swinging the panels in and out of the way. They are angled in such a way that they are flush against the wall all of the time. On those panels, you can use a brick pattern, a stuccoed pattern, and a black vinyl home-made effect on another.

The Ebony

This black vinyl background is made using a roll of black vinyl, cut to about eight feet and placed on the panel in a fanned out effect. We come in to just below the waist for this shot. It is a very good seller. For those of you who wish to be frugal, you may use a dark garbage bag.

5-5, 5-6 and 5-7 (this page): Window inserts can be hung on a rack in the high key area of the camera room. These window inserts can be used for a variety of different poses and settings. You can also use a spotlight to create a more visually exciting photo.

5-8 and 5-9 (opposite page, top): Here is an example of the ebony background.

5-10 and 5-11 (opposite page, bottom): Mini blinds also make for an interesting background. Notice the lighting set-up. Behind the blinds, you can either use fabric or a wall.

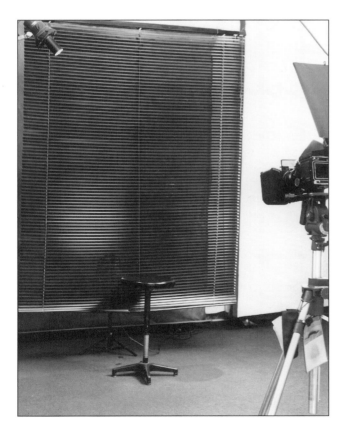

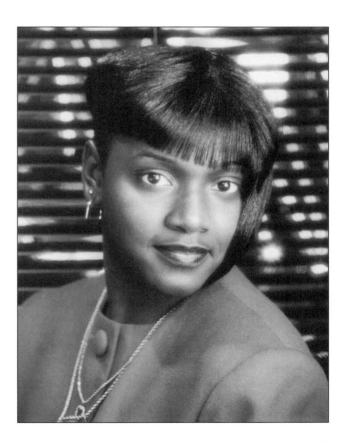

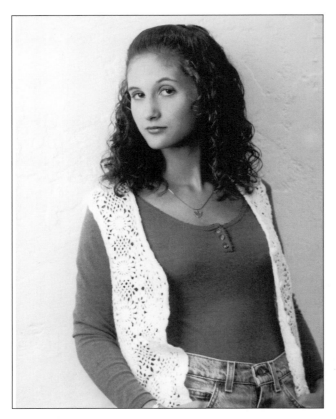

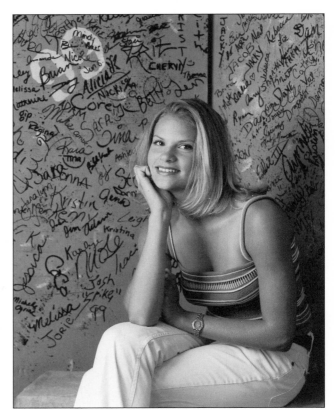

5-12 and 5-13: Three quarter length poses. The photo on the left uses a stucco panel as a background. The photo on the right was taken using the graffiti wall as a background.

To make the ebony background, starting in the middle of the piece, begin stapling your pleats fanning up and out and down and out, pulling while you are stapling. This background is used for girls. The subject stands in front of it, arms folded, her back almost touching the background. We come in to just below the waist for this shot. It is a very good seller. For those of you who wish to be frugal, you can use a dark garbage bag.

The Graffiti Wall Background

The graffiti background is made with two sheets of foam core board, although one 4x8 foot sheet will do nicely. This board is painted to look like a concrete block.

You will have to repaint this every year right over the names from the previous year. As the student approaches the wall, hand her a felt marker and ask her to sign in. Then you photograph her as she poses in front it.

The Muslin Backgrounds

Next to the graffiti area are two long muslin backgrounds (one ivory and one in"blue jeans" blue.) What the senior is wearing governs your decision as to which muslin will be used.

The muslin backgrounds are hung from the ceiling by a wooden dowel which holds the rings attached to the muslin. You can consider using a track on your ceiling similar to those that you hang sliding doors on.

Left: Three quarter length pose in the muslin area. He brought in his own jacket as a prop which was clamped to the background from the back.

Right: Using the spotlight and cookies, you can create unique and exciting portraits for your clients.

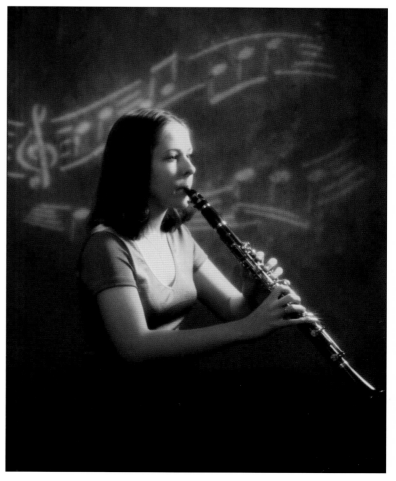

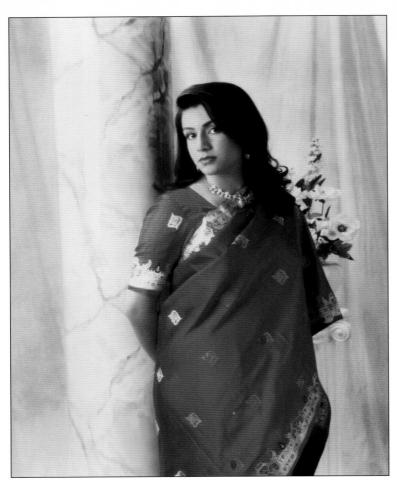

Left: The muslin background and pillar prop make a nice three quarter length portrait for this senior.

Right: The photo was taken in the high key area using a spotlight and a few props including a chair, vase and folding panel.

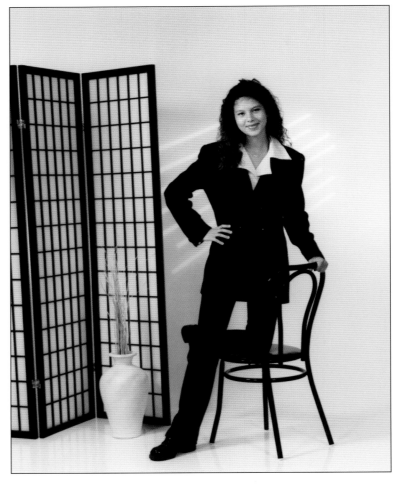

Right: Encourage your senior clients to bring in props that show their school activities and lifestyle.

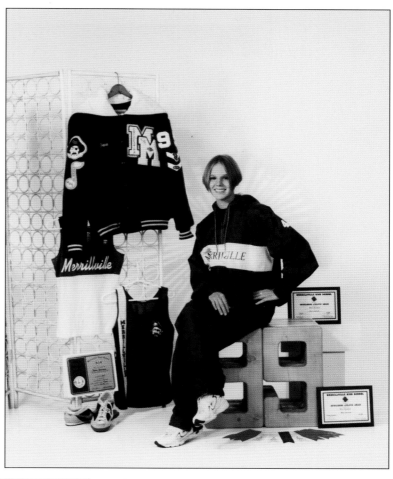

Left: Using props that the client brings in creates a unique photo that will be extra special for the senior.

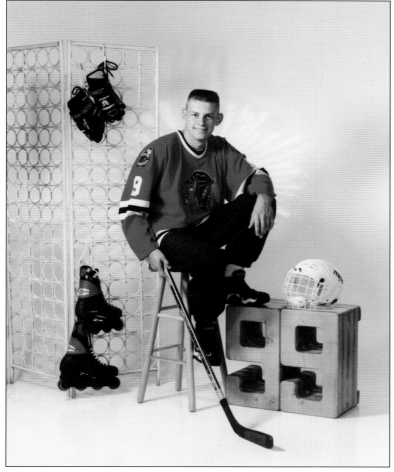

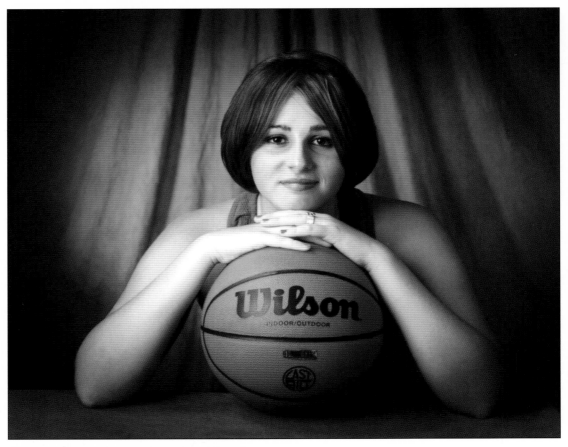

Athletics are often a big part of a senior's life. If the senior participates in a sport, make sure she brings in some of her equipment for props. Also, you can use lighting and colors to create a variety of backgrounds.

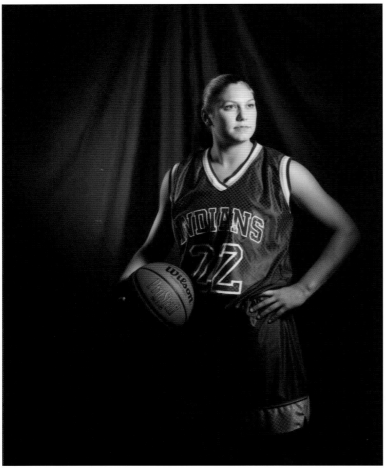

5-14: A full length casual pose using the muslin background.

The Rack

The rack is a 2x2x8 foot piece of wood with hooks on it used to hold the foam core boards or the window inserts. The rack, which is suspended on a pulley just above the full length area, serves as a clever way to display more background options.

When you lower the rack you can hang foam core board on it creating yet another background. These pieces of foam core board have various cut-outs and openings which allow the background area to be seen through the cut-out. When the rack is not in use, it is pulled up to the ceiling and totally out of the way.

You can hang a window on this rack which creates still another scene. There are window inserts, which you can buy at any lumber yard. These inserts fit on the inside of windows giving them that French door look.

By using a gelled background light, you can create some rather original images.

Full Length Backgrounds

The high key background is extremely easy to create. All you have to do is to use a roll of white seamless paper, nine feet wide, rolled out to four feet beyond where the subject is standing.

"The high key background is extremely easy to create."

5-15, 5-16 and 5-17: Here are examples of the different kind of backgrounds you can use for full length poses.

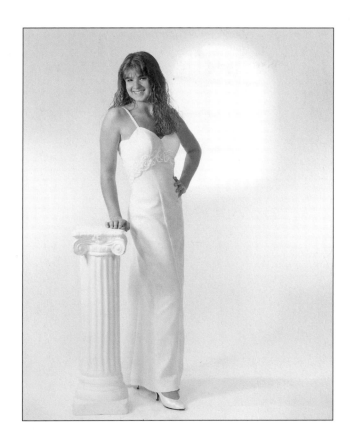

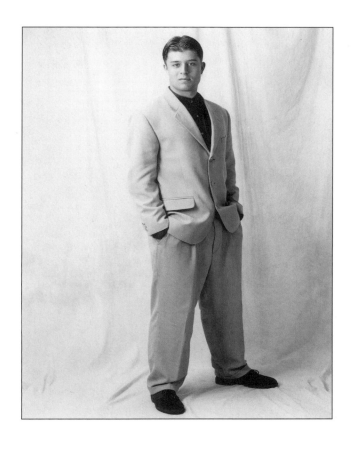

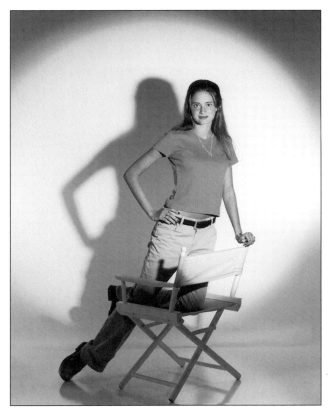

5-18, 5-19 and 5-20: These photos show how you can use the different kinds of backgrounds shown on the opposite page.

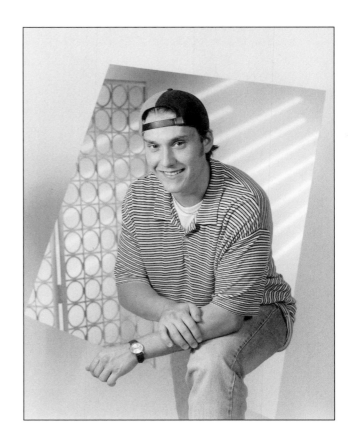

5-21: Here's an example of a cut-out you can make to create another background. You can also use a spotlight or other props for more options.

Another easy full length background can be made by using cut-outs. These are shapes that are cut out of the 4x8 foot foam core boards. Hang the boards on a rack and place a spotlight special effect on the seamless paper background behind the subject and the cut-out. By using a gel on either the spotlight and/or the background light, you can come up with some interesting variations.

CHAPTER SIX

Props

"...offer a multitude of options for you and your clients."

Props are like backgrounds in the sense that they offer a multitude of options for you and your clients. And, just like backgrounds, the more fun and unique props you have available, the more you increase your sales potential.

The Year Prop

This is a 2x1 foot wooden prop. It is made using a band saw to cut out eight bands of the numbers, and then stacking them together to form a strong piece of furniture forming the numbers of the current year. The pieces are stacked together by alternating with the grain and against the grain — five with the grain and three against the grain — much like a plywood effect to insure strength and stability. The pieces are fastened together with 3 inch dry wall screws and 1.5 pint of glue. It has a top so that the student can sit on it.

The Year Prop Pose

When posing a boy, have him sit on a tall stool. As he does so, ask him to prop the leg furthest from the camera up on the prop. The other leg is placed on the lowest brace of the stool. The furthest hand from the camera is placed on the higher knee, and the other hand is put on his thigh.

A girl will actually sit on the prop. If your prop will not support the weight of a senior, you may use a short stool directly behind the prop. There are a lot of ways to pose a girl with this prop. Here are two examples, but you can undoubtedly create many more poses.

1. As the girl sits on the prop, ask her to cross her knees. If she is facing to the right, put her right hand on her knee and her left-hand on the far end of the prop.

2. Ask the girl to kneel behind the prop as she places her hands on the top of the prop. You can vary this pose by putting her hands up to her face.

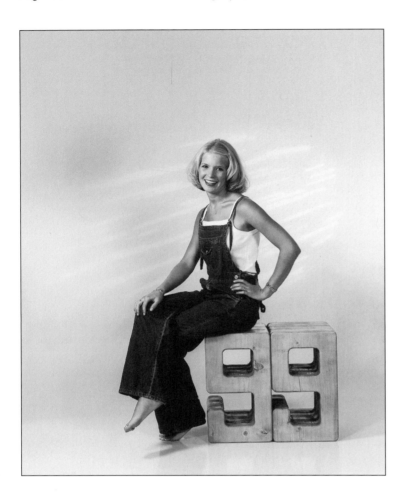

6-1 and 6-2: Examples of using props. The photo to the left shows the wooden year prop; the photo below shows the school block prop.

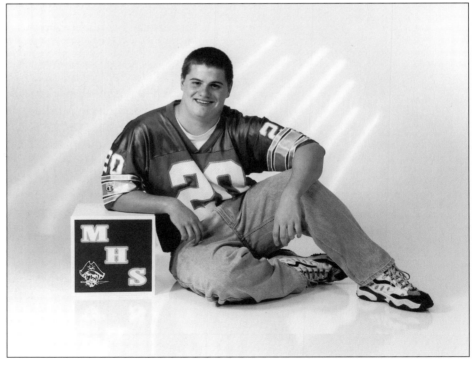

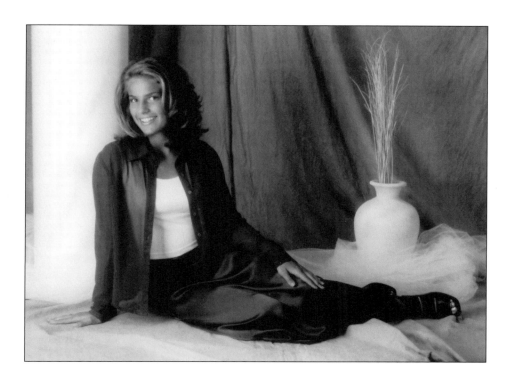

6-3 and 6-4: Other props that work well in full length portraits include various kinds of pillars, vases, and folding screens.

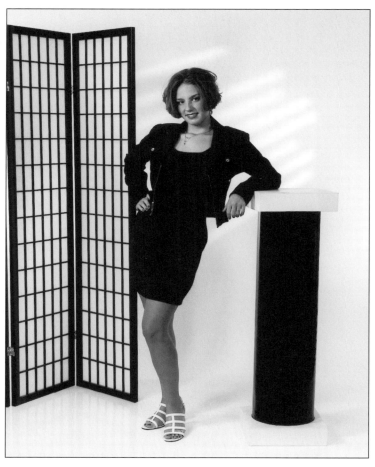

6-5 and 6-6: More examples of poses using the school block (left) and the year prop (right). Notice that both pictures also employ the use of a spotlight pattern on the background.

The School Block

This is a one foot block, the front of which has a piece of velcro on it to which you affix a plaque with the schools letters and colors on it. — and maybe the school logo. You can go to any quickie sign business and have them make the plaques. By using the better thicker material, you can use those plaques for a few years.

The School Block Pose

For posing either a boy or girl with this prop, start with having the subject sit on the floor. Then have him or her lean an elbow on the school block.

The Pillar

Go to a place that makes forms for cement columns which are used in highway building. They come in various diameters which allows you to choose the column size you need — the 12 inch diameter works best. They will cut it for you in the length you desire. After you wrap it with some vinyl, or even paper, you have a very nice looking pillar. You can also make a pillar from seamless paper with no form inside by rolling a 9 foot roll to about 4 foot and taping it so it won't unravel.

The Pillar Pose

This pose is usually reserved for girls. Ask the girl to pretend to lean on the pillar as she places her back up against it. Make sure the subject knows not to place her full weight against the prop pillar as it will not

6-7: Pillars make for elegant props when posing senior girls. This shot was taken using the muslin background and included two different pillars as well as a vase with flowers.

•Remember to encourage seniors to bring in their own props for a personal touch to their pictures.

take the weight. The hand closest to the camera lays by her side as it gently touches the pillar.

Other Props

While in the muslin and high key areas, you can use a multitude of props including many that the subjects will bring in depicting their school activities.

- The room divider. This is a free standing rattan screen used to hang any jackets, medals, or other attire that the senior wishes to display in his or her photograph.

- Cylinders. A set of cylinders of different heights can be made of rattan (look in Pier One stores).

- Pedestals. Pedestals of various heights with vases of flowers make interesting additions to many backgrounds.

- Blocks. A set of different size blocks used to set various personal props.

- A step ladder. Paint it white and use it with a high key or muslin background.

- The trophy holder. Easy to make, this tiered stand

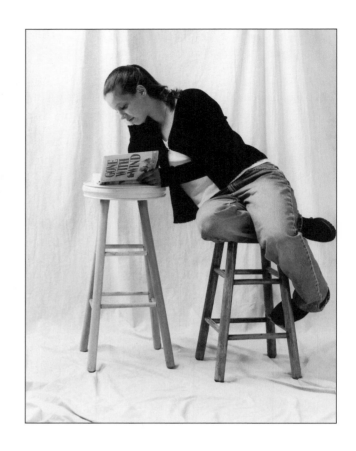

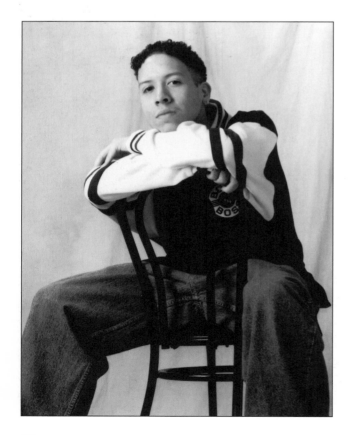

6-8, 6-9, 6-10, 6-11, 6-12 and 6-13: Many kinds of props can be used in senior portrait photography. Examples on this page include the year prop, stools and a simple chair. On the opposite page, these seniors brought in their own props, which held a special meaning for them — including cards and musical instruments.

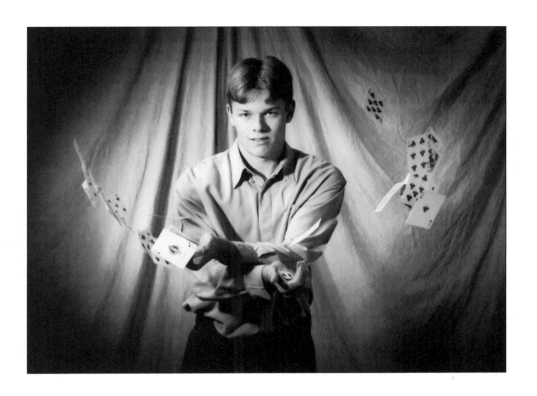

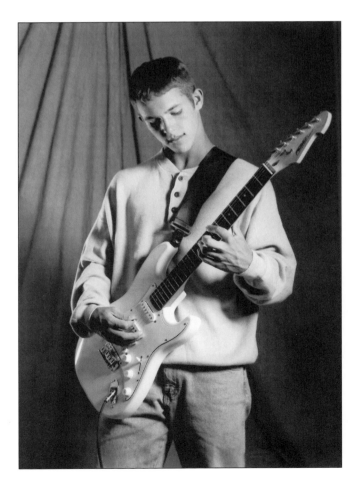

6-14 and 6-15: These photos were taken in the high key area of the camera room using the room divider as a rack for the letter jackets. Note that a spotlight was used to create patterns in the background.

takes care of easily displaying any trophies or awards. This prop is made up of three separate parts: 24x12x6 inches , 16x7x6 inches, and 8x5¾x6 inches. You can use these each separately or two or three together by stacking them. Each piece is grooved to hold the items needed to be displayed.

• The director's chair. This prop generally works better with girls. To pose, place the back of the chair facing the camera. Now have the girl place one knee on the chair seat. You can vary this pose by where you place her hands — one hand on the chair back and one hand on her hip creates a nice pose.

•The three tiered poser. With this poser, you can photograph music groups (bands), families and use it for only one person as we do in our graffiti set. This handy prop resembles a staircase with only three steps. Each step is a bit narrower than the next one starting with the widest at the top. It can be used with a muslin cover in a muslin setting.

• The spotlight. In some instances, this becomes a background. The background for many types of full length shots always includes a pattern created by the use of our spotlight with various cookies inserted.

"A 30 inch stool makes a very nice prop for girls or boys."

- The jacket holder. This free standing prop allows you to place the letterman's jacket on it for display next to the senior.

- The tall stool. A 30 inch stool makes a very nice prop for girls or boys. For posing, place the tall stool in the area. Then bring the subject alongside of it and lean his or her hand on the top of the stool. The other hand is placed on his or her hip. Now ask the subject to place his or her leg closest to the camera on the first support brace of the stool.

- The table poser. Used on every sitting, this adjustable up to 3 foot posing table is 12x28 inches. Covered with a cloth, this poser is a must for your studio.

6-16: A posing table, covered with a cloth, is a must for any studio. In this portrait, the hands were posed on the posing table and a fabric background was used.

CHAPTER SEVEN

Getting Along with the Lab

As you read this, understand I come from an era that had no color labs. Therefore, dealing with a lab was not something I had to do for the first five years or so in my business. In those days, we did all of our own processing, printing, and oil coloring. In fact, I did not switch to full color until 1972, although we did start doing weddings in color starting back in the early sixties. What follows are a few bits of information I have learned from some of the labs we have dealt with.

What the Lab Would Like Us to Know

Here are some of the things labs would like us to know that will help make the voyage from the studio, through their system and back to us by the promissory date a smooth one.

1. Read the catalog. Labs say some studios do not read their catalog well enough, especially the section that involves their particular order. Call the lab and discuss any ordering procedures relative to the kind of orders you will be sending in.

2. Make sure your instructions to the lab are clear. Labs claim studio's instructions are not easy to understand. Labs need clear and concise instructions in order to be able to successfully fill your order. A phone call to the proper lab person would obviously ensure that the instructions are understood.

3. Write clearly on glassines and work order envelopes. Fill out the glassines as that particular lab wants you to order and complete the order envelopes as your lab likes it done. This will expedite your order. Our biggest problem is make-overs; when that happens, we all lose.

4. Most labs do not appreciate two different formats packaged in one order envelope. Square formats should not be sent to the lab in an envelope with a 645, or 6x7, or

"Make sure your instructions to the lab are clear."

35mm. Keep formats packaged and shipped in their own order envelopes.

5. Be realistic about the actual delivery time from your lab. Many times studios will call the lab to inquire about an order that has not been in the lab long enough to be completed. If the catalog says it takes 10 to 13 working days, try to be tolerant of the true delivery date. Naturally, if your order is not ready by the expected date, you must make the lab aware of it. That is a good time to be assertive.

6. Find out about whether to mask your negatives or not. Some labs require you to mask everything. Others do not. You need to being aware of charges that will be incurred if you do not mask.

Selecting a Lab

It is important that you select a lab that will fill your type of photography needs. You should shop for a lab. When you find one, visit it and talk with the person who will be handling your account, and make sure they know what you expect, and can provide what you're looking for. However, do not assume the lab will know what you want.

Every time your particular order reaches the lab, it begins a trek through the plant and sometimes no less than a dozen people handle the order. When studios veer from the lab's rules, the orders will definitely be slowed down. Sometimes they even have to start from the beginning of the process. As soon as you choose a lab, learn your lab's system. Each lab needs you to follow their system so they can get your work out on time. Every time you go off the path, your orders will take longer to get back to you. Every lab I talked with stressed this fact.

Be informed of the technical part of our business. Labs believe that beginning studios are sometimes ignorant of the technical part of photography. Some studio requests are obviously technically impossible to service. All the more reason to let the lab educate your people.

Look for a good contact person at your lab who understands your needs and your particular way of ordering. We all need to feel secure that our problems are being taken care of. It has been my experience that every lab has someone like this person. Your mission is to find that person.

Shipping Your Orders

Most labs receive orders from the United States Mail Service, United Parcel Service, FedEx and many other private carriers. The mail service costs less but sometimes takes longer.

United Parcel seems to be favored by many labs, mainly because of its state of the art tracking capabilities.

Although the United States Mail very seldom lose an order, they do take longer to get an order to and from the lab. Labs count heavily on meeting the promised delivery dates. Therefore, they need to be assured

"... select a lab that will fill your type of photography needs."

that time spent in transition is kept to a minimum, and deliveries are consistent. In getting the order to and from the lab, both services private and US Mail are very reliable.

For consistency of delivery and a shorter length of time spent in transition, United Parcel Service is far ahead. Some labs will reimburse any studio that sends their orders via UPS. I personally have never lost an order in the United States mail. True enough, some orders have been delayed, mislaid, and defrayed, but they've always gotten there. Find out how your lab wants your work shipped.

Here is a good tip. When shipping small items via UPS., put that small box in a bigger box. UPS is geared for larger boxes, which can mean that your little box can sometimes be accidentally shoved in the back of the truck causing a bit of a delay until the next driver sees it. The United States Mail is geared more for smaller packages, which allows them to deliver your smaller package very well.

What Do You Want from the Lab

As far as I am concerned, all labs do a relatively good job. With video analyzers being what they are today, I am convinced that all labs can give you saleable quality. That is a given. Where we begin to drift into muddy waters is in the service end of the business. Ask yourself the following questions:

1. Does the lab get my work back to me on time?

2. Is the order correct?

3. Is the color good?

As far as the studio is concerned, these questions get to the heart of a good lab. Anything you can do to assist the lab to achieve these goals is to your advantage. You must communicate well with your lab and vice versa. If you have the mentality that the lab is working for you and, therefore, they must do everything you say because you pay them, you will probably have continuous lab problems. The studios need labs as much as labs need studios, so it is to everyone's best interest to let each other know the problems as they occur.

If you, as a studio owner, handle the business with your lab correctly, you can get a lot of favors done in the course of your relationship. I don't think you should ever leave a lab in anger. It should be done in such a manner that you can easily come back if you want or need to. You just never know when you might have to use that particular lab again and you don't want ill will affecting the service and quality you receive from them.

•**Customer service is vital when choosing and working with a lab.**

CHAPTER EIGHT

The Digital Revolution

I consider myself extremely lucky to have been involved with quite a few photographic revolutions during my tenure as a photographer. When I bought my first studio, I just missed the flash powder era, although the former owner did give me some flash powder and a tray. When I started, hot lights were used in the studio and flash bulbs were what we worked with on location. Then along came those cumbersome and very noisy electronic flash units. Imagine no more burned fingers, scorched pews or cartons of bulbs to lug around. Right about then 8mm movies came out and that was going to put all of the wedding photographers out of business. But what happened in 1960 is something that I can very easily liken to what is happening now.

Kodak came out with color film. It was unheard of to produce a color print from negative film. Up until then, all portraits in color were individually hand tinted or colored. We as photographers were now able to give our customers their portraits in *living* color. The big problem was that developing color film was such an involved procedure, requiring the purchase of some rather high priced processors, that it was obvious the average studio was not going to be able develop their own color.

There was the opportunity for a few far-sighted entrepreneurs to step in and fill the need to process and print color pictures for the studios. Many photographers resisted at first, citing that customers wouldn't pay the extra cost since we would have to pay the labs to process the film. Well the rest is history, color did fine and most photographers came on the color bandwagon. Those who did not grasp the fact that color was here to stay were left behind. Which brings us to the next revolution in photography — the digital revolution.

As the digital possibilities are now available to us, it is to our advantage as photographers to learn all we can about this exciting way of producing portraits. I am not suggesting you should go out and spend $100,000 on what is needed to set up a digital studio. What I am going to discuss in this chapter are some of the options you can consider

"... it is to our advantage as photographers to learn all we can ..."

when it comes to your individual needs as it pertains to the digital revolution. Having just visited a full digital studio in Fort Wayne, Indiana, I can tell you that digital is definitely here and doing quite well. On the other hand, let me warn you that it may not be the way to go during the infancy of this ever-changing medium. Although my trip to Fort Wayne was extremely worthwhile, it did point out the fact that the average studio was not going to be able do what this studio did, as well as they are doing it.

Realizing we must all get involved with digital in some way, I am suggesting we get educated and trained to use special computer software, such as Adobe PhotoShop, so we will be able to do some in-house print enhancement when it is our turn to take the bold step into digital photography.

Some Advantages of a Full Digital Studio

1. Lab Control. When color came in, we as photographers lost our darkroom talents as we turned them over to the labs. With the advent of digital manipulation, we are now back in the darkroom as we can have complete control over our finished product.

2. Instant ordering. Ten minutes after the session, you are showing previews, getting an order and collecting your money.

3. Same Day Service. In the case of all your commercial accounts, which require newsletter releases or publicity pictures, you can show previews and then make the glossies right then.

Some Disadvantages of a Full Digital Studio

1. Your Lighting. Your lighting creativity is somewhat stifled. Digital backs cannot reproduce high lighting ratios very well. 3 to 1 is as high as you can go (at the time of this writing). In other words, digital photos have problems in the shadows areas. Therefore you need to use flat light in order to achieve good results. Those photographers who oppose digital photography claim the prints all lack the "snap" they feel is needed to produce a normal print, although the photos are certainly of saleable quality.

2. Longevity. No one really knows how long these prints will go before beginning to fade. 39 years is a figure I am told by many in the trade.

3. Cost prohibitive. The equipment needed to start a complete digital photography studio can be expensive and therefore cost prohibitive.

"Make sure you stick with a higher-end printer for quality's sake."

Digital Equipment

Cameras – I think the best way to go at this time is using digital backs with chips in them allowing you to insert a PCMCIA card (much like a modem card) with 250 MB which can output 41 exposures. Most of your major camera manufactures are scrambling to make backs to fill the needs of digital minded. Kodak DCS 1 seems to be the leader at this writing. Nikon, Cannon, and some of the medium format cameras also have or will have backs soon.

Card reader – This device is a plug in to the software program Adobe PhotoShop. A card reader reads the information before it goes into the hard drive and can be manipulated before sending the previews to the selling room.

Scanners – There are many scanners on the market today. You probably want to stick with a higher-end product. Many computer stores sell scanners for under $300, but these will not give you the quality needed for a professional studio. Some of the best high-end scanners are made by Agfa (the Arcus II is a good example).

Printers – Again, there are many printers available. Make sure you stick with a higher-end printer for quality's sake. The Fuji 3000 and 4000 are good examples.

Computer – Certainly the computer you are working with can work if it can handle a lot of RAM. However, everyone I talked with stated emphatically the Macintosh G3 is the only way to go. How much RAM? 250 MB or as much as you can afford.

Software – There are several programs that can do photo manipulation, but it seems that the Adobe PhotoShop software package has become the industry standard. PhotoShop is an expensive program, but for digital photography, it is a must.

Monitors – In addition to the monitors for each of your computer stations, you will need a monitor for all your selling areas as well.

How to Join the Revolution

I am sure you will agree that to survive in the 21st century you will have to possess the capability and the know-how to do some digital work in your studio. There are some things you can do to join the digital revolution:

1. Get Adobe PhotoShop and do what is necessary to learn it.

2. Consider getting a Macintosh computer.

3. Buy all the RAM you can afford.

4. Get a good scanner.

What to do With this Equipment

In my opinion, you should move slowly during this revolution. Technology will change, prices will come down, processes will evolve. Meanwhile, let me list some work you can be doing in the world of digital photography as you get a feel for where this all is heading.

1. Composites. With the use of a scanner, and the previews, you can make individually stylized composites of the seniors as an add on to some of your packages. You should charge well for these as they will help you pay for your investment.

2. Wallets. Using the same procedure as above, you can create "designer" wallets, which will feature designs you have created on your computer made specially for that senior.

3. Restorations. You should do some restoration work. This can be a high profit item, since you will be eliminating the lab print enhancing and artwork fees. Of course, you should still charge your normal fee. You will do all of the corrections in-house and hand the lab a disk with all of the info on it and all you pay for is the print.

While what I have detailed is oversimplified, it still gives you an idea what you should be doing as you test the waters. A good rule to remember is to make sure you charge enough to be able to pay for your investment within two years, because your equipment will no doubt be obsolete by then.

My final thought on this next change in our business is to go slowly, but do get involved in this new process with at least some of the items I mentioned above. Just as color was the way of the future when I was starting, digital is the way of the future now as I am departing. Just as they told me then, "Color is here to stay, learn all about it," I am saying to you now, "Digital is here to stay, learn all you can about it."

"... make sure you charge enough to be able to pay for your investment ..."

Chapter Nine

Promoting Your Studio

"The key to survival is to be sales oriented."

In order to be successful in the photography business today, you must first consider yourself a business person, then a photographer. The key to survival is to be sales oriented. The more you learn about running a business, the better off you will be down the road. In addition to attending programs on lighting and posing, you must get a hefty portion of learning on how to market your skills.

Study the photographers who know how to market their product, implement some of their ideas, and you will succeed. Give me an average photographer in the camera room with a keen sense of marketing abilities, add to that a people-oriented receptionist, and I will show you a successful photography studio.

Marketing Your Studio

The first thing you have to do is begin letting everybody know who you are, what you do and where you are located. You are competing for the discretionary dollar which means you have other competition besides your photographic competitors — the jewelers, the sports stores, the gift shops, the electronics stores, and all the other merchants who compete for the same dollars. The more effort you put on how to get people to spend their money in your studio, the more successful you will be.

Inexpensive Projects for Starters

There are several ways to get your studio known without spending a lot of money. Always be watchful of your budget, but even more so in the beginning of your business. You should therefore place your emphasis on getting known with the least amount of cash outlay.

Civic Organizations

Right from the start you can join a civic organization such as Rotary, Lions, Kiwanis, or church groups. Your library has a complete list of every club in your town. Every town has more than a few, which means

you can be rather selective if you wish. Instantly you now have fifty or so new potential clients, and you are on a first name basis with every one of them. Get involved with community affairs. Volunteer your services for town functions. Put on informative programs for any local civic organization. Once the other civic club program chairpersons find out about your willingness to do this, you are going to be one busy celebrity. And eventually so will your studio. (This is easy to do, it will get you known, and it is free!)

Get Your Name in the Newspaper

I call it free ink. For example, I ran in local running races — "Local photographer runs in marathon." Half the time I didn't even finish, but I got my name in the paper. The whole idea is to get involved and get your name in the paper. Find a way that works for you. You can sponsor events, such as a run or a walk for charity that will surely get written up in your local newspaper. This also gives you an opportunity to get some good advertising for your studio before and during the event itself as your logo will be on the banners, posters and signs related to the event.

Displays

There are a lot of places you can set up a display advertising your studio. For example, look into your local county fair or even home-type shows that would welcome your business. For a fee, you are allowed to set up a booth and display your beautiful photographs and meet new people. Libraries allow artists to display their work. Set up a display at your library. You can look for other locations that would allow you to display your work, such as banks, malls etc. Restaurants are another source well suited to displaying your work.

Direct Mail

Direct mail is a great way to get known. One of the biggest reasons I bought a computer in 1987 was to send out direct mail. Direct mail is really a rather inexpensive way to get your message out. The key to direct mail is volume and frequency. Don't expect to get a tremendous response after the first mailing. Remember, whether they respond or not, you have reached that person with your name. Keep your name in front of the public any way you can. It will eventually pay off. The idea is to make your name synonymous with the word photography, and specifically senior photography.

Newsletter

Another idea is to publish a newsletter. This newsletter can tell your prospective senior customers and their parents what is new at your studio and specials on senior packages. Again, computers and software can do all of this for you.

The Yellow Pages

You do not need a large ad. Sometimes a new owner wants to make a statement so he buys the biggest ad of all the photographers. In my opinion this is not a wise investment in the early stages of your

"Restaurants are another source well suited to displaying your work."

"Compare each newspaper's circulation with their rates."

career. A reasonably sized, well done ad will suffice. Put your savings from a big ad to a smaller one into your direct mail campaign. One more thing about the yellow pages. These days it seems there are more than one yellow pages for a town or community. Make sure you are advertising with the yellow pages that will benefit you most. Be on the lookout for look-alike yellow page direct mail ads. Make sure you're dealing with the real thing.

Newspaper Advertising

Advertising in a newspaper can be rather tricky. You must consider newspaper advertising as a means of keeping your name in front of the public. Many times there is more than one newspaper in a town. Often there might be a daily and a weekly newspaper. It is in your best interest to contact each of the sales people, and write down their rates. In the beginning, the weekly might be a wiser choice. Compare each newspaper's circulation with their rates. Newspapers charge by what they call a column inch.

For instance, if your ad goes across two columns and goes down four inches, you will multiply two times four and get your column inches for that particular ad. Some newspapers have a lower rate if you buy a contract. They call this a contract rate. You are spending less per inch, but you are agreeing to buy X amount of inches that you can use over time. For example, you can buy 120 inches to be used within a 12 month period. If you definitely know you are going to advertise in that paper, it is to your advantage to purchase the contract rate.

Even if you do not have anything to advertise in a given month, you will get a rate holder so you can fulfill your minimal contract agreement. (A rate holder is a small box which will appear every week in which you can put your name or a message or even a picture if you wish.) Do I suggest advertising for you? You better believe it. Even if you don't get the expected response, advertising does pay.

Billboard Advertising

This is still another vehicle for publicity. Check it out in your town. Ask if they have a rotary sign program in which the sign appears in different locations every month. You may find it is not as expensive as you have assumed. When I did it, I was trying to convey a message to my clients which was, "If he can afford a billboard, maybe he is doing well. If he is doing well, maybe he is good; consequently if he is good, then I want to go to him." How can you afford it? Easy, just limit all of your other advertising that year.

Airplane Advertising

Have an airplane with your banner fly over a high school football game. If your town has more than one high school, and they are playing on the same day or evening, have the airplane fly over each game.

These are just a few advertising ideas. Check out your local library or bookstore for more books on marketing, advertising and promotion. The key to advertising, especially in the first few years of business, is to get the most exposure for your advertising dollar.

CHAPTER TEN

The Promotional Calendar

This is an effort to put down on paper exactly what it was I did to survive in this business for forty years. Some of the information in this chapter will be taken from a policy manual I made, and a lot of it will be the thoughts of many years as well as I can recall them.

The heart of this chapter will encompass a month by month calendar which you can use to keep focused throughout the year.

My Philosophy

- Work from a "To Do" list every day. My list goes with me all day long. So does a note pad used to put down any thoughts I have relative to my business throughout the day.

- Do not start your day in neutral. Tell yourself you are going to get something done today. Program yourself to win.

- Be a double timer, which means try to do more than one thing at a time. Listening to motivational tapes while driving is an example of double timing. You can also plan while working out. My most productive double timing was when I was training for marathon running. While running or any kind of work-out, you can plan your week, rehearse a presentation, or think about anything that would relate to your studio.

- Even when you are at home, watching television, you should have your notepad with you, in case a thought enters your mind.

- When you learn to delegate duties, and allow others to lighten your load, you will learn to love it.

- Hire good help, and have the "good sense" to let them ease your load. You can't do everything yourself, even if you think you can do it better.

"Do not start your day in neutral."

- Realize your strengths. Do what you do best. Delegate the duties you do not enjoy, and the chores in which you are weak, then step aside and let them get done.

- Have weekly meetings. Listen to your staff.

- You must learn to prioritize. Each day when you come in, you need to make quick decisions relative to what is going to be done and who will do it. Realize that on certain days you will have to re-order priorities as "stuff happens" in the course of your day. If you can't get the list done, get the important things done.

- Don't sweat the small stuff. If you get swamped by large projects, cut them up into smaller projects and do them one at a time.

- Don't spend time worrying about decisions. It's OK to do some research if you are concerned but don't get hung up; make the decision and move on.

- Sometimes it's a good idea to switch from a task for a while if you are running out of gas. Tell an employee to take a ten minute break when he feels frazzled. It is better than blowing up in front of a customer or making a critical error on an order.

- I feel it is important to have a life when the studio is closed. To me, this relaxation outside of photography is a necessary part of a healthy business.

- Avoid working on a project obsessively in an effort to make it perfect. A product with zero defects doesn't exist.

- Every year in January, when things are a little slower, it is a good time to reflect.

- Keep a diary or a daily log (which could be your appointment book). You can write anything that will help you for the coming year. You can make very good use of this appointment book by recording everything that is pertinent to events that will be repeated the following year. It serves as another log which will help you schedule events for the next season. Included can be items such as when you started certain schools, how many came in, when you sent the glossies to the lab and so on. Any information you think you will need to know for next year is put down. What needs to be done this next year has already been detailed in the appointment book, as well as your diary.

With that in mind, the first thing you do in January is get both of the appointment books and begin putting down into next year's appoint-

"... do some research if you are concerned but don't get hung up ..."

ment book what will be helpful for this year's scheduling. This allows you to use it as a blueprint for the new year.

Yearly Calendar

This month by month calendar provides ideas for promotions and details what activities should be done. As with every business venture, timing is crucial and pre-planning a must. You can use this calendar as a blueprint and modify it depending on what senior photography services you plan to offer your customers.

January

Sit down with your staff and look at your price list and contemplate possible additions or deletions. Talk about the previous year — consider any changes, praise the employees. Have weekly meetings (all year). Your employees are the ones who are dealing with your customers one on one. It is in your best interest to listen to them often. Many of the best ideas will come from interested employees. This is your way of checking the pulse of your customers.

January is a slow business time for studios. One way to pick up business is to run a senior wallet special. Tell your seniors about it in a mailer. This letter should include a wallet special, a family certificate, your frame sale, and any other literature you can stuff in it to have it weigh the full ounce. This letter goes to all seniors who placed an order with you previously. It works well because graduation is fast approaching, which means they are looking for a quantity of wallets to put in their invitations.

Another idea is to send out a 16x20 inch sample letter. This letter goes to every senior you think will make a good "model" for a sample you display in your studio for the new class. The letter asks them to give you permission to use their photographs in your studio as display portraits. It gives them three options:

1. I do not give you permission to use my picture.

2. You have permission to use my picture.

3. Yes, and I also wish to purchase my portrait after you are finished using it for display.

If they choose the last option, ask them to send in a check with their order and receive an additional $15.00 off the regular price. Give the senior a choice as to which photograph will be displayed. When these envelopes come back, yank out the checks first, then stack the letters in piles of those who gave you permission, those who did not, and those who paid. Find the negatives of those who paid, take them to your lab and order a 16x20 inch print. You should ask the lab for a price break.

In January, you should also plan to visit a principal of a school whose senior contract you will be seeking.

February

Have a frame sale. Send out direct mail about your annual frame sale. Most people cannot resist buying something at a store if it happens

NEED MORE WALLETS FOR FAMILY, FRIENDS AND GRADUATION ANNOUNCEMENTS?

Now is the time to order more wallet size portraits at special, very low prices…these are not copies! Each photograph is made from the original negative, rendering all of the definition, clarity and color brilliance that only an original negative can produce.

This special offer is available to any senior who has purchased and paid for an order! **You do not have to pay our normal re-order set up fee of $9.00 with this special offer!** This is a limited offer…so you must place your order now! If you order by mail, we will ship your wallet reorder to you **FREE!** Send your check, your name, address, phone number, school, and the pose you want and we will do the rest…add 5% sales tax of course. You can even reorder your typeset or hand-written imprint on these wallets at no charge (please call for details).

Call 769-7934 for more information.
Here are our special wallet prices: (from same pose)

24 wallets only $28	**32 wallets** only $33
40 wallets only **$40** *(our 40th Anniversary Special)*	**48 wallets** only $43
64 wallets only $49	**80 wallets** only $59
96 wallets only $69	**200 wallets** only $89

**Please add $9.00 set up per pose if ordering from more than 1 pose or from a new pose.*

ALSO AVAILABLE - LAST CHANCE PREVIEW SALE!!!

Any remaining previews can be purchased for only $4.00 each! You are welcome to come and browse through the previews you left behind - they can still make great gifts at only $4.00 each!

THE ABOVE SPECIALS EXPIRE APRIL 30th

Please send or bring in example of pose(s) you want to assure your order is processed correctly.
Payment is due in full at time of order - Sorry, no "Hold" order(s).

"This promotion is a
good deal for everyone
concerned ..."

to have a price with an X through it and another price next to it. I use the two marked down approach.

Get rid of those frames you got stuck with. During the sale, your studio looks like a storm came through it with stuff strewn about everywhere. Frames are big business these days. Run a frame sale ad in the newspaper. Put a sign in your window: "Up to 50% and even more off any frame."

Another idea to get business jump-started in February is to advertise specials on elementary or underclass photo packages. Who knows? Maybe seniors aren't the only ones wanting to get their picture taken by a professional quality studio photographer.

March

The re-visited special is really a big production in March for us. Every senior who was photographed in the past year gets a letter asking if he or she would like to appear in the re-visited display. These portraits will be displayed in your gallery for the month of April. The letter goes on to ask the senior to give you permission to put his or her picture in your re-visited gallery. It also tells the senior that he or she may purchase this portrait for only X dollars when you are through with the display in June. The size of the picture is an 11x14 and is priced very low. Most everyone who gets this letter realizes this is a very good price.

It is an opportunity to purchase a portrait that your customers otherwise couldn't afford at the original purchase time. In other words, they know it's a good deal, even if it smacks of a promotion. The exciting part of this promotion is coming to the studio every morning and finding envelopes with checks in them shoved under your door. When the envelopes come in, stack them in piles – those who have paid and those who haven't. Find the paid negatives and take them to your lab and get a special price on these 11x14's. When they come back, hang them up in one of your selling nooks every which way you can.

What about those in the stack of people who did not pay but gave permission to use their portraits? Well, what about them? If someone comes in to view their picture in our gallery and can't find it, quickly look through your stack of those who did not pay, you will most likely find it there. Tell them that you got such a large response, the pictures will be put up in shifts in order to accommodate everyone who responded. Let them know it will be up in about two weeks. Next, find that negative and get it to the lab. Needless to say, when that person comes back, it will definitely be up there. This promotion is a good deal for everyone concerned; you get some needed cash flow, while the customer gets a very good break on an 11x14.

March is also the month to plan your senior brochure and to get it ready for mailing. Gather all the possible photos you will be using on your brochure; work on your layout; and have it ready to go to the printer. Once you have a nice layout, you can use the same layout for the next year. All you do is change the pictures and the year. Set a target date for April 1 and have the brochure paste up or sketch with all the necessary information ready to go to a printer. Any local quick-printer should be able to print this for you.

"Your main effort should be your senior appointment letters and flyers."

April

This is get flyers and appointment letters ready month. Your main effort should be your senior appointment letters and flyers. The appointment letters as well as the flyers which go to your non-contract schools are both the same on the outside.

The message, however, changes on the inside depending on whether it's going to go to a contract senior or a non-contract senior. If you have a school contract, the appointment letter is just what it implies — it is sent to all seniors who attend your contract schools and gives them an appointment time to be photographed. Order just enough of those to cover the total number of students in your contract schools.

The other flyers will have information and coupons which can be used to purchase photographs from your studio. The letter invites them to come to you for their senior portraits. The top half of the flyer is devoted to letting them know what you do and why they should come to you, while the lower portion of the letter consists of coupons. Send out three mailings, changing the main offer slightly each time. As the year progresses, offer a little bit less on the main attraction.

Another good idea for this month is to make a senior picture display to be set up in a display case at the various schools. Target date for putting those up should be in the middle of May.

May

May is get ready for senior month. Everything you do this month is devoted to your senior seasons. This system involves pre-stuffing all of your envelopes with order cards, preview mailer and post cards. Reason? When the first student comes in, he or she will get a pre-stuffed, pre-numbered negative envelope which has everything needed to write up that seniors sitting. You need to do everything you can during the slow time because once "zoo" time arrives, you had better be ready. Are those appointment letters ready? Are those flyers ready? The appointment letters to the first contract school should be mailed out around May 28[t].

June

This month ushers in the beginning of "zoo" time at a senior studio as we start photographing seniors. Get out your first mailing of non-contract flyers or other direct mail. Hire all the help you will need.

July

This month the action continues as you photograph seniors. It is time to prepare the text for the next non-contract mailing and get it ready for the printer.

August

This month continues the pattern as you photograph more seniors. However now you will be at peak performance in the work room also. Mail the second mailing to the non-contract seniors.

September

Still photographing seniors and also delivering finished orders.

"... you might even get some our your competitor's customers who were dissatisfied ..."

October and November

Your senior season will be pretty much over. Finish delivery of all orders. You might also be prepared to schedule a few more senior sittings — some are stragglers, some may be your customers wanting another sitting, or you might even get some our your competitor's customers who were dissatisfied and want you to do a late senior sitting.

December

Run a Christmas gift certificate advertisement. This is a great time to get past senior clients and their families in for a group portrait — while everyone is home for the holidays. Be sure to decorate the studio. This should be a team affair as it helps to get everyone in the Christmas spirit and it also shows your employees how well they did during the year.

Conclusion

"...some thoughts that will help as you deal with seniors."

Based on my many years of photographing seniors I have compiled some thoughts that will help as you deal with them.

The Mindset of a Senior

When you get a chance to photograph seniors, remember they have just left their junior year and are about to enter their last year of high school. Although they are extremely excited that they have made it, at last, to the pinnacle of their high school career, they are filled with anxiety about what is ahead for them. While most of them know that college is in their future, they do realize this will be the last year with these friends. Many of their classmates have been with them since junior high and even before. Therefore the realization that this is their final high school hurrah weighs heavily on their minds.

The next item of business that enters their minds is the fact that they are now where they always wanted to be — at the top, the big "senior," looking down on the lowly underclassmen. Somehow they feel different walking down the same halls where they used to idolize last year's seniors. They feel important, they feel special, they feel admired, they look good, and so they begin to act like it. They have arrived and they want to have fun in their final year. Now we are going to discuss what it will be like dealing with the senior in the camera room.

That dreaded senior picture is no longer what it used to be. We have come a long way from the march into the gym where they sat on your camera case in front of your camera and defied you to take a decent picture of them. When I took my own survey, I found that now they actually look forward to coming to the studio for their senior picture. This really is a great time to be a senior photographer.

Girls

Most girls will want your better sittings. They will choose sittings that offer:

- More poses.
- More changes of clothing.
- The sitting that has more time spent with them.

Girls are generally agreeable to trying out new poses, and on the average, lend themselves to a larger variety of photo options.

If any problems crop up, it is usually a hair conflict. Mom wants the hair arranged one way and the senior is insisting that her hair is already just the way she wants it.

Although we enjoy it when the parent is in the camera room, we always ask the senior if it is all right.

Boys

In the past, the boys took the less hassle-type sittings; however, now that trend is changing rapidly. More boys are now taking the better sittings. When you are working with the boys that are taking your yearbook sitting only, you may notice a slight resistance to posing for that picture.

On the other hand, boys that do choose the sittings with more poses and backgrounds are just as easy to pose as the girls.

Guys who bring in their own props, such as athletic garb, musical instruments, cars, motorcycles etc., really get involved with the session and are quite willing to do whatever is needed to come up with that great portrait.

Questions You Should be Prepared to Answer

- Question: "Will my pictures all be retouched?"
 Answer: "Of course, all of your pictures will be retouched, except for your hair — that will remain as you see it on this preview."

- Question: "Will my portraits look exactly like the previews?"
 Answer: "For the most part yes, although your finished prints will be fully color corrected, completely retouched, and printed on the paper surface of your choice."

- Question: "Why does this pose look "fuzzy?"
 Answer: "Actually they are not "fuzzy." All of our bust type portraits are taken with a special softening lens which helps create a more pleasing bust type portrait. As you can see by these portraits on the wall, your finished portrait will not be fuzzy as you say...it will be beautiful."

- Question: "I don't like any of these."
 Answer: "What is it about them that you object to? Maybe our lab can correct the problem." Get to the problem right away. If it is an expression problem, a re-sitting is warranted. If you know you messed up, ask the person to come back at no charge. If you know the customer is a definite problem case, and you did the best you could producing some very good shots, charge him or her for a re-sitting and explain that they may not be any better (I'll bet you that when she comes back

"More boys are now taking the better sittings."

she will have a different hair style and a brand new outfit). You will find that most re-sittings are the fault of the customer. It is either hair or clothing or both. If it is the color of the suit that is being objected to, tell them you will work with the lab to re-produce that color for them.

We all know that when push comes to shove, our customer is always right. However, I have found that in most of our senior re-take situations you can bet the reason was either the clothing they wore or the way they did their hair. In both of these types of instances you should charge a re-sitting fee. If you were at fault, call the senior back for a no charge re-sitting. You must use good judgement when you deal with these scenarios. Most of the time they can be handled very easily. I will summarize with something I always tell the customer when I am called in to decide on a re-take or a do-over: "Mrs Smith, be assured there is no way you will leave my studio unhappy. We will either re-make the order until it meets with you and your son (or daughter's) approval or we will re-photograph your child and give you a another set of previews."

In closing, let me remind you anything you can do to make sittings fun will work in your favor many times over. If you have performed well, that senior (and his or her parents) will tell others. That is why that first year you photograph seniors is critical. Make them feel wanted — make them feel comfortable and allow them to have fun in the process. Do this and see your business grow and flourish.

"...the first year you photograph seniors is critical."

Appendix

The following pages give examples from the Giolas Photography, Inc. brochure of senior portrait packages they offer. Included are session fees, sample packages and additions to an order.

The payment terms cited on the Giolas brochure are as follows:

- Session fee is payable on the day the client is photographed

- $50.00 advance payment to pick up previews and take them out of studio — not refundable after 30 days

- 50% advance payment due when placing an order

- Minimum order required

- Extra items in packages may not be traded or substituted for previews or portraits

- Previews returned after due date will be billed to the client at portrait prices

- Preview returns by appointment only

Anytime you do a brochure, make sure it has the studio's name, address, phone number and hours of business. There's usually a lot of information that goes into the package/session brochure, try to make it as easy to read and understandable as possible. It's important to state the terms and include information on how to order, resittings, retouching and preview policies. You may also want to include an a la carte price list, wallet photo specials, preview purchase prices and any other special items you may have for seniors (wallet albums, magnet frames, extra poses, signature wallets, frame specials, etc.).

Another good idea is to have a brochure which provides information to help seniors prepare for their sessions at your studio. Make sure the senior gets the brochure in plenty of time before his scheduled session. Examples of information you can put in this brochure are on pages 85-86. The primary purpose of this brochure is to have clients that are well prepared and ready for their appointments when they come in for their senior portraits. Include *any* information you feel would be beneficial to your senior clients and their parents.

"... try to make it as easy to read and understandable as possible."

Session Fees

THE ULTRA 25-29 poses **$69.00**

The Ultra gives you the works! So plan to stay awhile for this session. Here's what you get:

- All of the Custom and Deluxe poses
- Fashion model posing
- Spotlight special effects
- Creative props and backgrounds
- Bring your own props
- Up to 4 outfits
- Contemporary lighting techniques

PLEASE call ahead for a special appointment since the Ultra sitting takes more time. We can not do the Ultra session without a special appointment!

THE DELUXE 16-19 poses **$54.00**

This is our most popular sitting! The Deluxe includes everything in The Custom (see below) sitting plus a larger selection of poses, with more props, and backgrounds, and our high key full length photography, if you wish. You may wear up to 3 outfits in this package.

THE CUSTOM 12-14 poses **$39.00**

The Custom offers the traditional head and shoulder poses with 2 backgrounds. You may wear up to 2 outfits. This package does NOT include full length poses.

Package Information

PORTRAIT FINISHES

Salon — Salon portraits are finishes on our finest portrait paper.

Opal — The Opal finish adds several applications of lustre spray, which completely seals your portrait.

Embassy — This is our finest finish. The brilliance and depth of color is further enhanced by the leather-like texture.

(You can see samples of each finish in our studio.)

WHAT ARE UNITS?

One 8x10 is 1 unit

Two 5x7's are 1 unit (both of same pose)

Four 4x5's are 1 unit (all of same pose)

Eight Wallets are 1 unit (all of same pose)

Sample Package Choices

THE EXTRAVAGANZA *Package Price:* $469.00

This seven pose package features a 20x24 Masterpiece portrait, mounted on a canvas board, then brush stroked to give the look and feel of an oil painting. All of your other prints are made using our Opal finish.

The Extravaganza package includes:

1 — 20x24 Canvas portrait
4 — 8x10's
8 — 5x7's
4 — 4x5's
120 wallets

- Seven poses
- Twelve previews
- Wallet album
- Family portrait
- Class of '99 T-shirt
- Magnet frame
- Signature wallets

THE MASTERS

Salon finish $299.00
Opal finish $359.00
Embassy finish $419.00

The Masters package includes:

1 — 16x20 embassy portrait
4 — 8x10's
8 — 5x7's
4 — 4x5's
104 wallets

- Four poses
- Eight previews
- Wallet album
- Family portrait
- Class '99 T-shirt
- Magnet frame
- Signature wallets

Sample Package Choices

THE EXECUTIVE

Salon finish	$259.00
Opal finish	$289.00
Embassy finish	$309.00

The Executive package includes:

1 — 11x14 portrait	• Three poses
4 — 8x10's	• Four previews
8 — 4x5's	• Signature wallets
56 wallets	• Family portrait

THE MIXER

This is our Mix and Match Special!

Salon finish	$189.00
Opal finish	$209.00
Embassy finish	$239.00

The Mixer package includes:

Nine Units...Any way you like 'em!

• Three poses	• Signature wallets
• Three previews	• Family portrait

THE THRIFTY

Salon finish	$149.00
Opal finish	$164.00
Embassy finish	$189.00

The Thrifty package includes:

2 — 8x10's	4 — 5x7's
48 wallets	

Price includes one pose. No substitutions!

THE SUPREME

Salon finish	$116.00
Opal finish	$139.00
Embassy finish	$155.00

The Supreme package includes:

1 — 8x10	2 — 5x7's
4 — 4x5's	16 wallets

Price includes one pose. No substitutions!

THE SPECIAL

Salon finish	$69.00
Opal finish	$89.00
Embassy finish	$94.00

The Special package includes:

1 — 8x10's	8 wallets

Price includes one pose.

Additions to Your Order

ADDING TO PACKAGES

SIZE	SALON	OPAL	EMBASSY
20x24	$139.00	$149.00	$169.00
16x20	99.00	109.00	139.00
11x14	69.00	79.00	89.00
8x10	29.00	33.00	39.00
2 - 5x7's	29.00	33.00	39.00
4 - 4x5's	29.00	33.00	39.00

CANVAS PORTRAITS

For the look and feel of an oil painting! Any print in your order can be mounted and brush stroked on canvas for an additional cost of:

20x24	Add $70.00
16x20	Add $50.00
11x14	Add $30.00
8x10	Add $20.00

Important Information to Help You Enjoy Your Senior Portraits

What You Can Expect:

- Your session may take 10 to 150 minutes, depending on which sitting you choose.

- Any sitting fee is due at the time of your sitting.

- You may keep the previews for 10 days after receiving them, then please call to set up a preview return appointment to place an order.

- Normal delivery time of your finished portraits is up to 8 weeks, depending on the season.

- You will not appear in the yearbook if you are not photographed and/or do not return the previews before the school's deadline.

- Normal preview delivery time is two weeks. Previews will be mailed.

When You Order, You Need to:

- Decide which poses you want.

- Place 50% deposit to start order.

- Have an appointment.

- Have senior student along to sign form for signature on wallets if desired.

What Do I Wear?

When choosing your outfits, keep in mind the most important thing is that you like them. You'll want to bring as much variety as possible. Most seniors prefer wearing casual and dressy outfits. Avoid sleeveless or very short sleeves because upper arms can be very distracting and can make arms look larger than they are, especially for women. Bring more outfits than needed, our photographer can help you decide which ones will look best.

BOYS — for the more traditional portraits, a suit or sport coat with tie is good. Medium to dark sweaters photograph well. For casual photos, comfort is the rule, try: jeans, shirts, sweaters, shorts, sweatshirts, western outfits, for example. Make sure shirt collars are the right size.

GIRLS — bring the colors and outfits you feel best in. Bring dresses (even formals, if you wish), and sweaters

for the more traditional look. If you like an outfit, it's probably because you look good in it, so make sure you bring it! You may also wear one of our drapes, if desired.

SHOES — Often shoes will show, so they should compliment your clothing; changes may be necessary with different clothing styles. Don't forget the proper socks. You may choose to pose barefoot for some photos.

What Else Can I Bring?

Here's where the fun really begins! Make sure you bring your favorite hat, musical instrument, pet, sunglasses, letter jacket, uniform, sports props, or ANYTHING else you feel would show off the real you. Don't forget other activities too: collectibles, swimsuit, boom box, fishing or skiing gear — ANYTHING! Also, if you have a telephone in your room, bring it. No idea is too crazy. Since we'll only try a few poses with it, you have nothing to lose. *Some of your props may require the ULTRA session. No props will be used with the Custom or smaller sittings.*

Can I Bring Someone With Me?

Absolutely! Some people find it more comfortable to bring Mom or Dad, a friend, brother or sister along to help ease the "camera room jitters." You are welcome to bring someone with you, but because of space limitations, we may limit the number of people who accompany you in the camera room.

What About a Suntan?

Too much sun darkens your skin unnaturally, drys out your hair, makes skin appear shiny or greasy, and shows bags under your eyes. Strap marks will show as white marks on draped poses or bare shoulder poses. Keep your tan even. Don't overdo the sun for a portrait; it looks great, but use in moderation. **Sunburn or windburn is a real problem — cancel your appointment if burned.**

What About My Hair, Make-up, Glasses, Jewelry?

HAIR — try to have your haircut and/or perm at least one week before your session, to give it a chance to "fill in" a little. Don't try a radically different haircut or style — chances are you won't feel it expresses the "real you." Athletes — if possible, put off shaving your head until after your portraits have been taken. Don't change your style (cut, perm, shave or otherwise) afterwards until you have seen your previews and placed your order. We are not responsible for hair corrections.

MAKE-UP — (guys too) here's a quick hint that will greatly enhance your portraits. Just before your session, stand two feet in front of the mirror. Dab a small amount of cover-up make-up on any noticeable blemishes. That's it — if they're gone in the mirror, they'll be gone in your photographs!

GLASSES — if you wear glasses most of the time, you'll want to wear them in your portraits. To eliminate glare and reflections, call your optician and arrange to borrow a pair of empty frames like yours, or have the lenses removed from your own glasses. Some opticians will gladly do this for free (make sure you give them plenty of notice though). This totally eliminates glare and distortions and is the most important way to improve your portraits if you wear glasses. It doesn't take much effort — and it will sure make your pictures look better! Remember, we are not responsible for glass glare.

JEWELRY — avoid wearing flat jewelry as it can cause glare.

OTHER — Cold sores cannot be retouched — please reschedule if you have a cold sore. We also cannot retouch bruises or cuts. Please wait until they heal before taking your senior pictures.

How Much Money Should I Bring?

The only thing you need to bring to your session is the sitting fee. This covers the cost for the photographer's time with you plus the expenses for your portrait session. It does not include any photographs but it DOES include great senior photography!

What Can I Expect at My Photo Session?

First, expect to have a great time, because you will! It's OK to be a little nervous at first, but you'll soon relax with our easy-going manner and creative photography.

Plan on arriving 10 minutes or so before your scheduled time to freshen up and check your outfits. You can tell us which photographic styles you like best. Remember, we want you to have fun — and being late will only result in you feeling rushed and less time spent on your photography. Besides, if you arrive late, you may have to wait until another day to be photographed.

Be sure to wear one of your outfits to the session to save time. Pick the one that you consider most traditional. It's OK to bring more than the recommended number of outfits if you're not sure what would look best. Ask us which would be the most photogenic.

Don't forget to dab a little cover-up make-up on those noticeable blemishes — it will make each portrait look a lot nicer.

Please remember your session fee (cash, checks, MasterCard and Visa accepted).

If you're unsure of something or have ANY questions before, during or after your session, PLEASE ASK! We want you to feel comfortable so you can get the BEST POR-TRAITS of your lifetime!

Checklist to Bring
√ hat
√ uniform
√ instrument
√ sports outfit/equipment
√ sunglasses
√ swimsuit
√ stuffed animals
√ hobby items
√ sitting fee
√ letter jacket
√ telephone
√ pet
√ dress glasses (empty frames)
√ make-up
√ shoes
√ tie
√ assorted socks

Glossary

220 Film: Film that offers 24 exposures, or 20 exposures or 30 exposures depending on which camera format you use.

120 Film: Film that offers 10, 12, or 15 exposures depending on which camera format you use.

Background Light: This light is used to give the subject some separation from the background.

Bounce Flash: Flash that is bounced off the ceiling, a wall, an umbrella or a reflector, and then goes to the subject.

Broad Lighting: The highlight side of the face is closest to the camera.

Bust Pose: A head and shoulders pose.

Butterfly Lighting: Light coming from directly above the camera causing a shadow just below the nose.

Cookies: These are metal cutouts of patterns used in the spotlight to create patterns on the background.

Direct Flash: A light source that goes from flash head direct to the subject.

Fill Light: This light subtly fills in the shadows created by the main (or modeling) light.

Full Length: A pose that shows the entire body.

Gel: A heat resistant colored piece of plastic used to alter the color of a light.

Grip: This is the handle, if you will, with which you hold your camera for off-tripod shooting.

Hair Light: The light used to light the hair.

High Key: A lighting that puts four times the light on a white seamless background than it puts on the subject.

Interchangeable Film Back: A film back holder that allows you to change backs in mid roll, without exposing the film.

Kicker Light: Sometimes used as an additional light source to enhance the main light.

Lens Diffusion: A softening filter that is placed over the lens for a more pleasing blend of shadows and highlights.

Light Diffusion: Material placed in front of the light reflector giving you softer shadows.

Light Head: The flash that is powered by the power pack.

Light Ratio: The total amount of light falling upon the highlight side, relative to the shadow side. The ratio is expressed numerically.

Low Key: A lighting which puts no lighting, (or hardly any) on the old masters type dark background and produces slightly heavier shadows on the subject.

Main Light: This the light that creates the modeling of the portrait.

Medium Format Camera: A camera that exposes a film size between 2¼ and 3¼ inches.

Modeling: This refers to a light (as in main light) that creates the "modeling" of the face.

Muslin: Cloth in 9 and 12 feet widths and 15 foot lengths used as a backdrop. Comes in various colors and can be used on location as well as the studio.

Parabolic Lights: A light with a reflector which goes directly to the subject (as in a 16 inch reflector used as a main light).

Photo Cell: A light-sensitive device that uses the light from another flash to trigger any flash it is plugged into.

Power Pack: This unit powers the flash heads that are plugged into it.

Profile Lighting: Lighting coming in from the side into which the subject is looking and lights the forehead nose and chin. (Subject must be in a profile pose.)

Punch Light: A smaller light source used to add some "punch", or "snap" to a particular area of the portrait.

Quantum Batteries: A portable high capacity rechargeable battery used on any location photography.

Radio Device: Works with a transmitter on the main flash and a receiver on the 2nd flash as it uses a radio frequency to fire the flash units. (The main flash unit triggers the 2nd flash.)

Rembrandt Lighting: Lighting that comes from a 45 degree angle and places a triangle of light on the shadow side of the face (the side furthest from camera).

Short Lighting: The shadow side of the face is closest to the camera.

Snoot: An attachment over a light to bring that light down to a smaller area of coverage (as in hair or background light).

Soft Box: A light in a box that bounces light through baffled material and sends it out of the translucent front panel. Produces a soft forgiving wrap-around lighting effect.

Split Lighting: Light coming in from the side highlighting one side of the face only. (the shadow side is in compete shadow.)

Spotlight: This light, which produces a very intense sharp shadow, is used with "cookies" to create special effects on the background. Can be used as a main light also.

Telephoto Lens: Allows you to come in closer on portraits without getting distortion. (as in head and shoulder shots). In portrait photography this can also be called the portrait lens, and is usually 150mm lens.

Three-Quarter Length Pose: A pose that includes body down to the approximately the knees.

Top Light: This is lighting that is bounced off the ceiling directly above the subject in the full length area.

Tripod: A sturdy holder for all of your portrait photography.

Umbrella: A light bounced into a large umbrella. Creates a non direction light with a wide coverage.

Wide Angle Lens: A lens that gives a wider view of any subject without sacrificing distance from subject (as in large groups).

Zone Focus: Pre-focusing on an area, then when the subject gets to the designated spot, taking the picture.

Index

Other Books from Amherst Media, Inc.

Big Bucks Selling Your Photography
Cliff Hollenbeck

A complete photo business package for all photographers. Includes secrets to starting up a business, getting paid the right price, and creating successful portfolios. Set financial, marketing and creative goals. This book will help to organize business planning, bookkeeping, and taxes. $15.95 list, 6x9, 336p, order no. 1177.

Great Travel Photography
Cliff and Nancy Hollenbeck

Learn how to capture great travel photos from the Travel Photographer of the Year! Includes helpful travel and safety tips, equipment checklists, and much more! Packed full of photo examples from all over the world. $15.95 list, 7x10, 112p, b&w and color photos, index, glossary, appendices, order no. 1494.

Stock Photography
Ulrike Welsh

This book provides an inside look at the business of stock photography. Explore photographic techniques and business methods that will lead to success shooting stock photos — creating both excellent images and business opportunity. $29.95 list, 8½x11, 120p, 58 photos, index, order no. 1634.

Achieving the Ultimate Image
Ernst Wildi

Ernst Wildi shows any photographer how to take world class photos. Features: exposure, metering, the Zone System, composition, evaluating an image, and more! $29.95 list, 8½x11, 128p, 120 b&w and color photos, index, order no. 1628.

How to Shoot and Sell Sports Photography
David Arndt

A step-by-step guide for those seeking to develop the skills and knowledge necessary for success in the demanding field of sports photography. $29.95 list, 8½x11, 120p, 111 photos, index, order no. 1631.

Lighting Techniques for Photographers
Norm Kerr

This book teaches you to predict the effects of light in the final image. It covers the interplay of light qualities, as well as color compensation and manipulation of light and shadow. $29.95 list, 8½x11, 120p, 150+ color and b&w photos, index, order no. 1564.

Black & White Portrait Photography
Helen T. Boursier

Make money with b&w portrait photography. Learn from top b&w shooters! Studio and location techniques, with tips on preparing your subjects, selecting settings and wardrobe, lab techniques, and more! $29.95 list, 8½x11, 128p, 130+ photos, index, order no. 1626.

Computer Photography Handbook
Rob Sheppard

Learn to make the most of your photographs using computer technology! From creating images with digital cameras, to scanning prints and negatives, to manipulating images, you'll learn all the basics of digital imaging. $29.95 list, 8½x11, 128p, 150+ photos, index, order no. 1560.

Special Effects Photography Handbook
Elinor Stecker Orel

Create magic on film with special effects! Step-by-step instructions guide you through each effect, using things you probably have around the house. $29.95 list, 8½x11, 112p, 80+ color and b&w photos, index, glossary, order no. 1614.

Handcoloring Photographs Step-by-Step
Sandra Laird & Carey Chambers

Learn to handcolor photographs step-by-step with the new standard handcoloring reference. Covers a variety of coloring media. Includes colorful photographic examples. $29.95 list, 8½x11, 112p, 100+ color and b&w photos, order no. 1543.

Wedding Photographer's Handbook

Robert and Sheila Hurth

The complete step-by-step guide to succeeding in the exciting and profitable world of wedding photography. Shooting tips, equipment lists, must-get photo lists, business strategies, and much more! $24.95 list, 8½x11, 176p, index, b&w and color photos, diagrams, order no. 1485.

Black & White Nude Photography

Stan Trampe

This book teaches the essentials for beginning fine art nude photography. Includes info on finding your first models, selecting equipment, scenarios of a typical shoot, and more! Includes 60 photos taken with b&w and infrared films. $24.95 list, 8½x11, 112p, index, order no. 1592.

Lighting for People Photography

Stephen Crain

The complete guide to lighting. Includes: set-ups, equipment information, how to control strobe and natural lighting, diagrams, illustrations, and exercises for practicing lighting techniques. $29.95 list, 8½x11, 112p, b&w and color photos, glossary, index, order no. 1296.

Glamour Nude Photography

Robert and Sheila Hurth

Robert and Sheila Hurth guide you through shooting glamour nude photography. Includes shooting techniques, lighting, make-up and hairstyles, equipment, and more! $29.95 list, 8½x11, 144p, over 100 b&w and color photos, index, order no. 1499.

Infrared Photography Handbook

Laurie White

Covers black and white infrared photography: focus, lenses, film loading, film speed rating, batch testing, paper stocks, and filters. Black & white photos illustrate how IR film reacts. $29.95 list, 8½x11, 104p, 50 b&w photos, charts & diagrams, order no. 1419.

Black & White Model Photography

Bill Lemon

Create dramatic sensual images of models. Explore lighting, setting, equipment use, posing and composition with the author's discussion of 60 unique images. $29.95 list, 8½x11, 128p, 60 b&w photos and illustrations, index, order no. 1577.

The Art of Infrared Photography / 4th Edition

Joe Paduano

A practical guide to infrared photography from an artistic perspective. Includes: color infrared, digital infrared, anticipating effects, using filters, focusing, developing, printing, handcoloring, toning, and more! $29.95 list, 8½x11, 112p, order no. 1052.

Swimsuit Model Photography

Cliff Hollenbeck

A complete guide to swimsuit model photography. Find and work with models, select equipment, posing techniques, and much more! By the author of *Big Bucks Selling Your Photography* and *Great travel Photography*. $29.95 list, 8½x11, 112p, over 100 b&w and color photos, index, order no. 1605.

Infrared Nude Photography

Joseph Paduano

A stunning collection of images with how-to text which discusses how to shoot the infrared nude. Over 50 infrared photos presented as a portfolio of classic nude work. Shot on location in natural settings, including the Grand Canyon, Bryce Canyon and the New Jersey Shore. $29.95 list, 8½x11, 96p, over 50 photos, order no. 1080.

Fashion Model Photography

Billy Pegram

For the photographer interested in shooting commercial model assignments, or working with models to create portfolios. Composition, posing, selection of clothing, and more! $29.95 list, 8½x11, 120p, 58 photos, index, order no. 1640.

Professional Secrets of Advertising Photography

Paul Markow

No-nonsense information for those interested in the business of advertising photography. Includes: how to catch the attention of art directors, make the best bid, and produce the high-quality images your clients demand. $29.95 list, 8½x11, 128p, 80 photos, index, order no. 1638.

Professional Secrets for Photographing Children

Douglas Allen Box

Covers every aspect of photographing children on location and in the studio. Prepare children and parents for the shoot, capture a child's personality, and shoot story book themes. $29.95 list, 8½x11, 128p, 74 photos, index, order no. 1635.

How to Operate a Successful Photo Portrait Studio

John Giolas

Combines photographic techniques with practical business information to create a complete guide book for anyone interested in developing a portrait photography business. $29.95 list, 8½x11, 120p, 120 photos, index, order no. 1579.

Profitable Portrait Photography

Roger Berg

Learn to profit in the portrait photography business! Improve studio methods, lighting techniques and posing to get the best shot in the least time. $29.95 list, 8½x11, 104p, 120+ b&w and color photos, index, order no. 1570.

Family Portrait Photography

Helen T. Boursier

Tells how to operate a successful family portrait studio, including marketing family portraits, advertising, working with clients, posing, lighting, and selection of equipment. $29.95 list, 8½x11, 120p, 123 photos, index, order no. 1629.

Basic 35mm Photo Guide

Craig Alesse

Great for beginning photographers! Designed to teach 35mm basics step-by-step. Features the latest cameras. Includes: 35mm automatic and semi-automatic cameras, camera handling, *f*-stops, shutter speeds, and more! $12.95 list, 9x8, 112p, 178 photos, order no. 1051.

Amherst Media's Customer Registration Form

Please fill out this sheet and send or fax to receive free information about future publications from Amherst Media.

CUSTOMER INFORMATION

DATE

NAME

STREET OR BOX #

CITY **STATE**

ZIP CODE

PHONE () **FAX** ()

OPTIONAL INFORMATION

I BOUGHT *HIGH SCHOOL SENIOR PORTRAIT PHOTOGRAPHY* **BECAUSE**

I FOUND THESE CHAPTERS TO BE MOST USEFUL

I PURCHASED THE BOOK FROM

CITY **STATE**

I WOULD LIKE TO SEE MORE BOOKS ABOUT

I PURCHASE [] **BOOKS PER YEAR**

ADDITIONAL COMMENTS

FAX to: 1-800-622-3298

CUT ALONG DOTTED LINE

①

②

Name_____
Address_____
City_____State_____
Zip_____ — _____

**Amherst Media, Inc.
PO Box 586
Buffalo, NY 14226**

③